VITAL FORMS

Biological Art, Architecture, and the Dependencies of Life

JENNIFER JOHUNG

UNIVERSITY OF MINNESOTA PRESS
MINNEAPOLIS
LONDON

Chapter 1 was previously published in a different version as "Speculative Life: Art, Synthetic Biology, and Blueprints for the Unknown," *Theory, Culture, and Society* 33, no. 3 (May 2016): 175–88. Chapter 3 was previously published in a different version as "Choreographic Arrhythmias," *Leonardo* 48, no. 2 (April 2015): 172–73. Chapter 5 was previously published in a different version as "Demonstrable Plasticity," in *The Routledge Companion to Biology in Art and Architecture*, ed. Charissa N. Terranova and Meredith Tromble, 424–31 (New York: Routledge, 2017).

Published by the University of Minnesota Press
111 Third Avenue South, Suite 290
Minneapolis, MN 55401-2520
http://www.upress.umn.edu

Printed in the United States of America on acid-free paper

The University of Minnesota is an equal-opportunity educator and employer.

26 25 24 23 22 21 20 19 10 9 8 7 6 5 4 3 2 1

Library of Congress Cataloging-in-Publication Data
Names: Johung, Jennifer, author.
Title: Vital forms : biological art, architecture, and the dependencies of life / Jennifer Johung.
Description: Minneapolis : University of Minnesota Press, 2019. | Includes bibliographical
 references and index. |
Identifiers: LCCN 2018055268 (print) | ISBN 978-1-5179-0304-6 (hc) | ISBN 978-1-5179-0305-3 (pb)
Subjects: LCSH: Art and biology. | Architecture and biology. | Life (Biology).
Classification: LCC N72.B5 J64 2019 (print) | DDC 701/.08—dc23
LC record available at https://lccn.loc.gov/2018055268

For Arthur John

CONTENTS

VITAL DEPENDENCIES

I had spent little time inside a science lab since high school, but in the early wintery darkness of late January 2013, I flew across the Atlantic from Chicago to Helsinki to clock eight hours a day at Biofilia, Aalto University's new Base for Biological Arts, a fully functional biological laboratory operated by an art school and housed in an engineering department. Along with twenty-one other participants, mostly artists and designers, I arrived for an intensive weeklong Biotech for Artists workshop led by Oron Catts, director of SymbioticA, the Centre of Excellence in Biological Arts at the University of Western Australia, along with Biofilia resident lab manager Marika Hellman. As the only participating art and architectural historian, I was drawn to the workshop as a way to experience firsthand the material actualities of the biotechnological practices that launch the living art and architecture I had been researching and teaching, indeed that launched the writing of this book. With a background in performance theory, I was also interested in laboratory processes and procedures as they coincide with visual, spatial, and embodied modes of witnessing, caring for, and displaying the unfolding of matter, form, and environment. And I was terrified: While I had been slowly and secretly observing, I did not know this world of the laboratory, its languages, its modes of biological study and technological practice, its very ways of doing and being.

Nonetheless, along with my trepidation for a serious hands-on immersion, I carried these thoughts with me to bridge the unknowns:

the question of how and why we are generating, sustaining, situating, systematizing, and regenerating living matter is not only, and has never been only, a biological, chemical, or engineering question of technique or technology but has always instigated visual and spatial, philosophical and political platforms of dialogue. And we, in the arts and humanities, are already entangled in the conversation; our various systems for imaging, imagining, situating, building, and experiencing things and beings in the world are already being tested and revised, challenged and expanded by twenty-first-century modifications of living matter. As Hannah Landecker, with remarkable and incisive clarity, posits: "The usual formula, 'biotechnology changes what it means to be human,' should have an interim step included in it: 'biotechnology changes what it is to be biological.' This interim step is key to understanding the specificity of 'life' after biotechnology rather than 'life' after nineteenth-century physiology."[1] This step is also an opening where art and architecture may intervene—to visualize, situate, perform, publicize, and contest the ways in which we now manipulate and recontextualize the particulate mattering of biological life. While both living matter and its technological modifications are more viably becoming the tools and trade of contemporary artistic and architectural practices, art and architectural systems of making and receiving can, and should, actively participate in the ever-changing understanding of what forms life—determining and defining as well as composing and framing—in its most current micromanifestations.

So my lab partners and I donned our white lab coats and learned how to extract our own DNA, genetically manipulate bacteria to make it glow green, passage cells to develop healthy tissue cultures, seed those cells onto polymer scaffolds, and finally kill and dispose of the living forms we had been growing and transforming all week (Figure 1). While we each soon learned how to carefully follow through with these activities, our explorations were open-ended and without functional end goals. Indeed, in a larger sense it is not my goal to level what artists and scientists do into any kind of post-disciplinary equation or to support any perceived privileging of scientific discourse or progress, especially in relation to the arts. Rather, I aim to notice

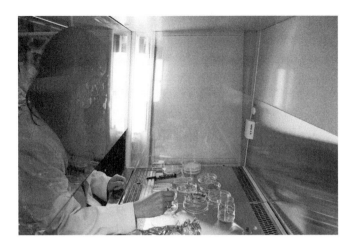

FIGURE 1. The author and the author's DNA, both at Biofilia Base for Biological Arts, Aalto University, Helsinki, Finland.

where moments of overlap may occur and when vectors of departure arise with respect to differing motivations and scales of intention.

In fact, what I did come away with was a renewed art historical understanding, a sense of certain familiarities in processes of making and methods of showing, which led me to believe that biological art could not be relegated to a special and separate form of contemporary technological arts practice (which is hardly ever included or taught in art history departments) but rather remains deeply engaged with wider art historical genealogies, of course including and yet significantly also beyond either the particularly biological or technocentric. Insomuch as our laboratory exercises, and the art and architectural works discussed throughout this book, cross from art project to science experiment and back again while sharing techniques and technologies, my primary concerns here are deeply rooted in the capacity for the arts to directly engage in the oftentimes ambiguous formations of what is it to be biological and living.

I began to think about some key definitions of biological art that intersect across contemporary art history more generally. Biological artists work with living matter—animal and plant cells, tissues, membranes, DNA, nucleotides, bacteria, and other particles and organisms—catalyzing, coaxing, modifying, and manipulating such material into living forms that move, transform, and die in ways that are oftentimes unpredictable. The vulnerable and delicate status of such matter is of central concern, as is the process required to fabricate and alter these living forms. Decades earlier, in the midsixties, artists such as Robert Morris, Robert Smithson, Eva Hesse, and Alan Saret were creating forms and generating processes that alluded to the body and its decomposition. Using nontraditional materials like latex, wax, felt, ice, and animal fat, these process artists arranged shapes that hung, fell, dropped, drooped, grew, condensed, and melted over time. Exposed to gravity, temperature, and weather, these perishable and transitory forms called attention to the ephemerality of living and dying matter, just as, on a microscale, biological matter remains vulnerably unstable, both evolving and disintegrating.

More specifically, then, biological artists work with living matter in

and across time. Biological art is alive and often occurs live; if aligned with performance art, both practices generate durational events that unfold in time, capitulating the doing of something in a specifically fleeting time and place. Much of early performance art foregrounds actions taken with a body and upon a body, actions that are sustained and endured with unavoidable frankness across time—from Carolee Schneemann covering her body in paint, grease, chalk, plastic, and ropes (*Eye Body,* 1962–63), to Vito Acconci's self-inflicted bite marks (*Trademarks,* 1970), to Chris Burden's shot arm (*Shoot,* 1971), to Marina Abramović allowing a room full of spectators to do whatever they wanted to her for six hours without consequence, using scissors, a knife, a whip, and, most notoriously, a gun and a single bullet (*Rhythm 0,* 1974), to name just a mere handful of infamous early examples. Emphasizing the limits and endurance of flesh, these performances elicited viewers to witness and engage with bodies that are affected and inflicted, to experience in direct proximity the tenuous liveness of those bodies. In dialogue with these experiential immediacies, biological art activates and entangles all manner of living forms across micro- to macroscales. Modifications, alterations, transformations, and even accidents occurring during the life processes of biological artworks are offered up live for viewers to witness, thereby implicating and associating their own bodily matter with the living and dying material in front of them.

So biological artists work with living matter in live time and in relation to other beings and things, living and nonliving, across a range of scales and temporalities. In addition to the living matter developed and manipulated in live time, biological artworks attune us to the sociocultural practices necessary to generate, sustain, and end life; these living forms need tending to, need to be fed, and, in most cases, killed at the end of the exhibition. In bringing new life into being, or in altering existing life, biological artists urge us to think about the layered contexts within which new qualifications of life are being determined and manipulated, as well as the encounters necessary to give and take life. Before and beyond biological art, installations and poststudio art practices that activate transactions between viewers also seek to

expand the framework of the art event to include social, economic, and cultural exchanges that occur across all dimensions of art production and reception and, ideally although quite rarely, beyond the art world altogether. Such relational art is contingently interactive; it provides the conditions to bring bodies temporarily together, to encourage them to act momentarily with each other, at the very least within the gallery environment. In turn, biological art provokes encounters and exchanges between living bodies as well as between nonhuman, semi-living, and nonliving things, manipulating various scales of matter, bodies, and environments, while making these exchanges legible to a wider audience beyond the enclosures of the laboratory.

In acknowledging these kinds of analogies across contemporary art history, albeit generalized with many more occurring well before the late twentieth century, I note key moments of convergence across processes of forming, conditioning, and contextualizing that situate biological art alongside more typically acknowledged art trajectories, specifically those that emphasize durational events and experiences traced in time and in relation to other living and dying material forms. Again, my point here is to recognize familiarities that might allow us to see certain contemporary art practices as necessarily already involved in processes of generating, framing, and displaying living and dying matter and bodies. In fact, my week in the lab made clear a commonality among almost all of the activities we were undertaking, which is that we were engaged in practices of first isolating and then building with living matter across time. From form-making to form-finding, practices of structuring, molding, sculpting, composing from two to three dimensions led me to turn from the art historical toward the architectural and also toward design. And so in a similar manner, I understand biological practices of forming with living matter, in time and in relation to other structures, bodies, and environments as necessarily intersecting with and meaningfully contextualized within a genealogy of contemporary architecture.

A shift in the conceptualization and materialization of structural forms has been underway for the last few decades, so that architecture can be conceived of as an inanimate object that is nonetheless enliv-

ened, responding to its environmental situation while also anticipating its inhabitants' changing needs. Materially animated and in tune with variable movements throughout the built site, architecture in practice and in theory has been moving toward performance-oriented vocabularies, design concepts, and methods of construction. Although contemporaneously termed, performative architecture arguably has roots in much earlier conceptualizations of a building's responsive relationship to its users, dwellers, and landscape.[2] Yet what remains at stake for contemporary architecture in approaching a performance framework for design, construction, and use is an understanding of a building as both a spatial structure and a temporal process of ongoing situation and fluctuation, in concert with the surrounding environment.

Today in step with digital modeling and fabrication technologies, buildings are successively designed and constructed as if they were living forms, inextricably driven by a multitude of contingent external and internal variables. We now ask, to borrow David Leatherbarrow's words: "In what ways does the building act?"[3] As an actor, architecture is afforded temporality, motion, and even emotion, as buildings are both generated and maintained as if they were bodies. But what makes an architectural body? In the 1990s, the American architect Greg Lynn began to incorporate animation and motion graphic software into the process of generating biomorphic structures, each that transforms and deforms according to a time-based system that calculates changing surface curvatures within a flexible set of parameters.[4] With emphasis on keyframing, in which the mathematics of infinitely small intervals can simulate motion, Lynn's structures dynamically and indeterminately evolve throughout the design process in ways that are not fully predictable and thus seem to have a life of their own. For the Dutch architect Kas Oosterhuis, this kind of "building-body," otherwise named as a "hyper-body," identifies a well-balanced and self-sustaining structural integrity, composed of a continuous, semipermeable, kinetic, interactive skin that bends exterior and interior spaces into and out of each other and that responds to variations in both the surroundings and the inhabitants.[5] These networked relations unfold in time, are variable and flexible, and are programmed as such. In addition,

these uncertain conflations of digital and phenomenological bodies and skins are also potentially emotive, capable of accepting and exuding affective registers that may gesture toward unforeseen aftermaths of responsive digital technologies.

As these digitally generative paradigms of architecture attend to the morphogenesis of structural forms as processes, effects, and affects occurring in time, buildings tend toward the lifelike. In fact, *morphogenesis* is a biological term that defines the ways in which forms develop, and architecture has interpreted this overlap between the biological and the structural in a number of ways. For Alberto T. Estévez of the Genetic Architecture Research Group based at the International University of Catalonia, Barcelona, digital design can be conceptualized as well as actualized and controlled by way of genetic manipulations. For example, Estévez has forwarded a proposal in which a bioluminescent protein (GFP) from a jellyfish *(Aequorea victoria)* can be inserted into the DNA of living plant cells in order to ultimately develop into trees and plants capable of illuminating the urban landscape of Barcelona.[6] The conflation of partly programmed objects and partly living materials belies, for Marcos Cruz and Steve Pike of the Bartlett School of Architecture in London, "neoplasmatic" tendencies in a contemporary architecture of emergent hybrid organs, organisms, and systems. In contradistinction to a top-down genocentric approach in which genomics and computation, and thus biology and engineering, are tightly intertwined, Cruz and Pike ask: "How are designers to understand design when it implies notions of programming, control and maintenance of cellular structures that grow, evolve and eventually mutate?"[7] The challenge to architects is, then, to incorporate as well as to respond to material systems that unpredictably vary over time, against and beyond controllable programs.

While generative digital technologies impel living structures to act and interact whether predictably or unpredictably, when aligned with biological systems the burgeoning forms of biomimetic architecture grow and evolve through their imitation of organic processes already occurring within living forms and across their environments.[8] Although organic phenomena and principles have influenced a range of modern

architects—Le Corbusier, Frank Lloyd Wright, Buckminster Fuller, and Frei Otto, among many others before their time—contemporary architecture's turn to the biological occurs within a constant destabilization of the purely natural toward that which is constructed, synthesized, hybridized, and unfixed. In tandem with biomimicry's imitations and allusions, contemporary biodesign seeks to harness organic processes with the ideal goal of correcting ecosystemic crises within our current biological, ecological, and geological climate, for, as William Myers suggests, "disaster looms if new biological inventions simply accelerate the current cycles of environmentally destructive design and building in the relentless pursuit of short-term gains."[9] With an eye toward the biodesigned long-term, Ginger Krieg Dosier has developed a BioBrick formed from a combination of sand, calcium chloride, and urea that prompts bacteria to form a solid material over time.[10] Henk Jonkers has induced cementation microbially, a process that directs bacteria to fill in cracked concrete with nutrient deposits in order to elongate the life span of buildings, roads, walls, and other structures.[11] For Mitchell Joachim of Terreform ONE, the shaping of growing trees over time is capable of providing habitable spaces; his *Fab Tree Hab* would develop over a removable plywood frame with branches woven together to construct walls, archways, and roofs.[12] And the examples go on. Working with instead of against biological processes, architecture can, as Janine Benyus argues, "begin to do what all well-adapted organisms have learned to do, which is to create conditions conducive to life."[13] Such a provocation urges architects, artists, and biologists alike to reconsider and re-emphasize the material processes, situations, and interactions that generate as well as sustain and support, repair and surrender living forms over time.

With these disciplinary genealogies serving as backdrop, this book is concerned with the ways in which contemporary biological art and architecture actively engage in the forming of life, both with and against the forms and times of biotechnological developments, and even more endemically the ways in which art and architecture—especially practices that are durational, performance-oriented and relational—are vitally necessary to current and changing formulations of life. We can

still only speak of life comparatively, according to phenomena that distinguish living organisms and systems from nonliving inorganic matter, even as these boundaries are becoming increasingly ambiguous. Although there is no unequivocal definition of life, living entities share common characteristics. They are self-sustaining and homeostatic. They grow, move, metabolize, transform, reproduce, communicate, and have complex organizational infrastructures that evolve over generations, adapting to changing external environments and emerging with new functional abilities.

In coining the phrase "life itself" at the turn of the twenty-first century, at the height of genetic engineering and at the cusp of synthetic biology's search to generate and standardize discrete biological parts, Nikolas Rose and Sarah Franklin each signaled a historic rupture, in both the conceptualization as well as the politics of life. Gesturing toward the instrumentalization of life in the age of recombinant DNA, life itself, according to Nikolas Rose, defines "our growing capacities to control, manage, engineer, reshape, and modulate the very vital capacities of human beings as living creatures."[14] These expansions in our bodily assessment, care, and manipulation in turn catalyze biopolitical shifts. As Rose outlines, the molecularization and optimization of living matter on a microscale open onto different expectations of how humans upkeep and respond to their failing bodies within new biomedical professions of somatic expertise that in turn feed into the constant search for new and different biocapital within ever-burgeoning bioeconomies.[15] Indeed, as Catherine Waldby contends, all manner of living matter and systems from cells, tissues, and organs now accrue "biovalue" to be sourced, enhanced, and exchanged, so as to in effect capitalize upon life.[16]

Michel Foucault has of course most famously theorized modernity's turn toward biopolitics; his concept of biopower—as extended by Giorgio Agamben, Michael Hardt, and Antonio Negri within political theory and revisited by Paul Rabinow and Nikolas Rose across sociology and anthropology—must be invoked here in accordance with biotechnological developments that strive for the efficient manipulation of living matter. To briefly rehearse such a trajectory: After the

eighteenth-century rise of a governance centered on bodily health and efficiency, the sovereign power to "let live" and "take life" was replaced, according to Foucault, by a new modern biopolitics that instantiated the right to "make live" and "let die."[17] For Hardt and Negri, any such power over life is still fundamentally dependent on the domination and exploitation of some for the benefit of others.[18] Agamben's thanatopolitics, in turn, sees all power as functioning through the possibility of enforcing death.[19] Against these uptakes that highlight exceptional forms of biopower, Nikolas Rose and Paul Rabinow argue for a return to Foucault that focuses on actual collective strategies that intervene in the name of life and health, mobilizing new forms of "biosociality" as, for example, "cystic fibrosis groups cut across national and class barriers as do their care givers . . . [and as] models of patient activism spread, and are taken up and reinterpreted from Bangladesh to Toronto."[20] In the midst of such reinterpretations and deviations, "life itself" for Sarah Franklin "has displaced traditional ideas about the domain of the natural, and become the locus, and means of expression, for new forms of cultural production (including biological ones)."[21] Thus, as living matter is reassembled and regulated from the microcellular to the geopolitical, life itself becomes the site of our own constant redefinition, both individually for ourselves and collectively with others.

Yet we must also recognize that the controlled instrumentalization of life itself, which initially was tied to genomics, has already had to encompass a less centralized and more capacious understanding of how genes operate in concert with a range of biochemical activities both within and outside of the cell. Much has been written about the dismantling of our wishful presumptions concerning the genetic master plan of living forms, but perhaps this is put most strongly and succinctly by Evelyn Fox Keller when she contends that in the twentieth century, "the century of the gene," we have been forced to reckon with "how large the gap between genetic 'information' and biological meaning really is."[22] Information cannot be rendered so easily or directly into predictably stable and sustained outcomes; instead, the translation of genetic information into material characteristics and

functions as well as embodied events and actions is greatly colored by contextual particularities that inevitably vary in time. Following upon a long line of thinkers—including Keller, Richard Lewontin, and Donna Haraway—Samantha Frost makes an even broader claim when she argues:

> There is no überbiological matter in a cell, in a body. What this means is that far from being isolated, constitutionally durable, and materially infallible things, genes—and proteins and cells and living bodies—are biocultural phenomena. Because they are biocultural, we must always think of them in terms of a living organism that responds to its needs over time, through its life history, in a specific context, and in response to events.[23]

So from genes to bodies, no form of living matter can ever be exclusively framed within stable biological terms but rather is always determined according to and situated alongside other entities, occurrences, and environments in the past and into the future.

Undergirding such a claim, the field of epigenetics explores how genetic material interacts with environmental contexts over time, so that the evolution of living forms, the manipulation of living matter, and the determination of life itself are not exclusively top-down translations of genetic code but rather proceed as flexible genetic expressions in relation to specific external situations that occur across generations. According to Catherine Malabou, epigenetics upsets our ability to determine any stable characteristic of living forms in both spatial and temporal isolation. She writes: "Epigenetics allows us to question the definition of the living being as a set of functions; secondly, it makes it possible to question the definition of the living being as a program; and thirdly, it blurs the dividing line between the fact of living and the elaboration of a mode of being."[24] Unsettling any translatable and determinable genetic program that directs living forms into being, epigenetics for Malabou (along with cloning and regenerative technologies) lays the groundwork for her claim that the potential to resist the instrumentalization of life may actually emerge from within the devel-

opmental biological structure of living matter. This is a significant moment in Malabou's thinking, and one that deeply influences the undercurrents of this book, because she asks us to recognize how resistance to human directives taken upon and with life is catalyzed within the "bio" itself rather than instigated externally through philosophical thought or biopolitical concept. In fact, as exemplified through each of the art and architectural works that form the core of the book's trajectory, biological forms themselves are unpredictable, ever-variable, and thus potentially able to persist and transform alongside a number of forces across time, never fully stabilizing even under human control. And yet even so, the pursuit of control continues; in fact, now we must contend with CRISPR (clustered regularly interspaced short palindromic repeats)/Cas9, a technique that currently offers us the capacity to edit genomes with increased precision and efficiency.[25]

Therefore, in consideration of contemporary biology's shift away from the centrality of the gene as the defining script of a living organism in tandem with biotechnological developments that nonetheless continue aiming for the controlled manipulation of life, this book asks: How and why do particular biological art and architectural practices participate in the formation of living matter—initiating, sculpting, modifying, and resisting? To what extent do these practices formulate life—defining, determining, qualifying, and contesting? While the case studies that I take up across this book are by no means extensive, nor are they meant to speak for the totality of their growing fields in the way that a survey might, the projects that I do address offer what I believe to be thematic consistencies that emerge as I consider the above questions. Engaging with particular advances in synthetic biology, tissue engineering, the form and function of the extracellular matrix, systems biology, and stem cell science, the biological art and architectural works considered throughout the book each engage in the processes and thus temporalities of forming life by positioning vulnerable encounters and performing uneven exchanges across a differing range and scale of materials, from organic to synthetic, micro to macro, and with the participation of both living and nonliving matter.

Offering intertwined yet unequal correlations of matter, these encounters and exchanges across time are responsible for synthesizing, maintaining, contextualizing, systematizing, and regenerating new and existing forms of life (processes that outline the book's narrative arc), as well as biological, technological, and political qualifications of life and the living.

This brings me to the title of the book, which posits that biological art, architecture, and the forming of life are entangled in relations of dependency that are both vitally necessary and vitally unforeseen. To begin with, *vitality* is not a term that can be used easily, as we know when acknowledging its position as a counterpoint to materialism within the history of science. Arising in contrast to the chemical identifications, physical definitions, and properties of living matter, the philosophy of vitalism historically attributes an inexplicable, nonmaterial force to the activities of life. But unlike those who ascribed a spiritual soul to life's incalculability, twentieth-century critical modern vitalists sought to honor scientific developments while also acknowledging the indeterminate nature of living things. In the early twentieth century, Henri Bergson named this enigmatic life force that escapes full control and definition *élan vital*. For Bergson, "The biologist who proceeds as a geometrician is too ready to take advantage here of our inability to give a precise and general definition of individuality. A perfect definition applies only to a *completed* reality; now, vital properties are never entirely realized, though always on the way to become so; they are not so much *states* as *tendencies*."[26] Matter is never inert or stable, while life is always in the process of becoming, as it "appeals to some inner directing principle"; this is élan vital, "the tremendous internal push . . . the impulse which thrusts life into the world."[27] This generative force or productive impetus is multidirectional, diverse, uncontained, and unpredictable; it manifolds and flourishes disassociatively between and among beings and things, injecting indeterminism as the foundational element of any kind of material formation. Against both materialism, "in which the totality of the real is postulated complete in eternity," and finalism, which "implies that things and beings

merely realize a programme previously arranged," Bergson's élan vital does not exist prior to, nor is it planned before, its enactment through and within living forms and activities that are always in process.[28]

Revisited by Gilles Deleuze at the end of the twentieth century, Bergson's élan vital is direction without a goal, ignition toward but without an end. For Deleuze, this creative force with which, from which, and through which life emerges does not belong to nor can it be defined alongside organic or inorganic matter; it renders these distinctions between beginning and end, among form, process, direction, and action, indiscernible and irrelevant.[29] As Deleuze argues: "Life as *movement* alienates itself in the material *form* that it creates; by actualizing itself, by differentiating itself, it loses 'contact with the rest of itself.' Every species is thus an arrest of movement; it could be said that the living being turns on itself and *closes itself.*"[30] Here we see how Bergson's qualification of "creative evolution" as continuity through heterogeneity remains integral to Deleuze's own emphasis on multiplicity and divergence. For both, the unity of form through differentiation (and thus the determination of cells to species) is generated by life's original, common, and unending vital impulse. This vitality is unknowable in its affordance of emergent temporality that formulates ever-new, transitional, and disassociative forms through time, across various scales and contexts.

A lesser-known contemporary of Bergson's, the embryologist Hans Driesch, made similar attempts to decipher and name life's vital force. Initially put forth in his 1907–8 lecture series *The Science and Philosophy of the Organism,* Driesch's notion of entelechy has recently been contextualized alongside Bergson's concept of élan vital by political theorist Jane Bennett. Borrowing the term from Aristotle for its articulation of a self-propelling impulse, Driesch's entelechy formulates and arranges emergent possibilities before they become actualized within or as an organism; entelechy is, in his words, "an agent *sui generis,* non-material and non-spatial, but acting into space, so to speak; an agent, however, that belongs to nature."[31] As such, it is inexplicably responsible for rendering the potentiality of life. And according to Bennett:

> Neither *élan vital* nor entelechy is *reducible* to the material and
> energetic forces that each inhabits and must enlist; both are
> *agents* in the sense of engaging in actions that are more than
> reflexes, instincts, or prefigured responses to stimuli; both have
> the generative power to produce, organize and enliven matter,
> though Driesch emphasizes the arranging and directing powers
> of the vital agent and Bergson accents its sparking and innovating
> capacities.[32]

In opposition to mechanistic examinations of life, élan vital and en-
telechy are attempts to think the vitality of life as always escaping defi-
nition and quantification, and by extension both are at work inside and
outside of all kinds of material realities: embodied to inert, organic to
inorganic, living to nonliving, alive to dead.

While the mid-twentieth-century rise of biochemistry along with
the subsequent discovery of DNA addressed the question of molecu-
lar life in physiochemical terms, nonetheless in acknowledgment of
an open field of variable, dynamic collaborations among living mat-
ter, a revised concept of vitality is once again emerging, intercutting
the previously distinct camps of vitalists and materialists with a new
merged vital materialism. Across the disciplines of geography, phi-
losophy, and political science, this new materialism, implicit but never
fully claimed by critical modern vitalists, forwards an even stronger
proposal: that matter is active and, with an indeterminately unstable
force, impetus, and direction, matter also has agency, which has con-
ventionally been ascribed exclusively to living humans. In their edited
volume *New Materialisms,* Diana Coole and Samantha Frost argue,
"The human species is being relocated within a natural environment
whose material forces themselves manifest certain agentic capacities
and in which the domain of unintended or unanticipated effects is
considerably broadened. Matter is no longer imagined here as a mas-
sive, opaque plenitude but is constantly forming and reforming in
unexpected ways."[33] For Rosi Braidotti, this posthuman "intelligent
vitality" is a "self-organizing force that is not confined within feedback
loops internal to the individual human self, but is present in all liv-

ing matter."[34] Thus, in affirming matter's own vital force whose activity and efficacy exceeds human action and purpose, new materialism intersects with vitalism, confusing precise boundaries and attending to material formations beyond the living altogether. Turning to Jane Bennett again, vital materialism seeks "to paint a positive ontology of vibrant matter . . . to dissipate the onto-theological binaries of life/matter, human/animal, will/determination, and inorganic/organic . . . to sketch a style of political analysis that can better account for the contributions of nonhuman actants."[35] Both Bennett and Braidotti have found inspiration in Baruch Spinoza's monistic concept of the unity of matter, in which all matter is of the same substance, as well as his notion of "conative bodies" that are intensified in their alliances with other forms and bodies.[36] Therefore, in superseding fixed and discrete distinctions between the matter around and within us, this new vital materialism reconsiders the status and requalifies the relational impact of living and nonliving forms, structures, and systems within the material world at large.

Although a definitive vitalism seems all but irrelevant to contemporary biology's quest to isolate and molecularize, as well as to current biotechnologies that seek to catalyze and control particulate matter, we may nonetheless consider vitalism's generative and formative impulses alongside, entangled with, and not necessarily opposed to the physiochemical characteristics as well as the expanded agentic plenitude and self-organizing processes acknowledged by both old and new materialism as intrinsic to life. Considering "the vitality of vitalism," Monica Greco revisits Georges Canguilhem's proposal that vitalism should be "an imperative rather than a method and more of an ethical system, perhaps, than a theory."[37] For the philosopher of science writing in the middle of the twentieth century, all life struggles, adjusts, and transforms spontaneously in order to persist in variable environments over time. In Greco's remix, then, if vitalism's own historic and unrelenting imperative has been its constant materialist refusal, then that imperative has been "superseded by the need to account for its permanent recurrence."[38] And here I am once more, asserting that we

reapproach vitality as a persistent condition rather than as a qualification or definition of life that endures alongside the physicality of materialism and that refuses any steadfast binary relation of vitality and materiality. Instead this vital condition frames the temporal openings through which new material formations and relationalities reside as contingent latencies both within and significantly beyond the living, openings that occur through the ongoing and unevenly distributed generation, maintenance, disintegration, and reintegration of things and beings over time.

Across this book by way of a select group of art and architectural works, I chart out this proposal: What is vital to biological life in our age of biotechnological manipulations, and yet what always escapes complete determination and instrumentalization and thus may act as potential sites of resistance and contestation, are the dependencies between and among matter of various kinds, scales, and times. As Karen Barad reminds us: "Independent objects are abstract notions. . . . The actual objective referent is the phenomenon."[39] With quantum physics in tow, Barad affirms the entanglement of materiality, or the ways in which "boundaries, properties, and meanings are differentially enacted through the intra-activity of mattering."[40] For Barad, objects emerge through their encounters and relations rather than existing prior to them. These particular, performative, and agential intra-actions sediment material configurations in specific situations and yet also continuously offer the possibility of reconfiguration and re-entanglement across time due to the indeterminacy of material boundedness. Scaling up from the quantum, Barad notably entreats us to remain attentive and responsible for "our active engagement of sedimenting out the world in certain kinds of ways and not others"—which inevitably speaks to the forceful and complex macroscale power imbalances that condition these processes of ongoing configuration and entanglement.[41] Here we must keep in our minds both the philosophical legacy and continued enforcing of biopolitics embedded in seemingly neutral determinations of how material forms are bounded, according to and for whom, as well as who gets to reform and renew as well as resist and contest those boundaries.

In such a spirit of attunement to these larger resonances beyond the pages of this book, I choose the term *dependency* in order to invest in a mode of relationality that acknowledges and reclaims processes of leaning, holding, and positioning one thing up against another. Scaling up and down, from the micro to the macro and back again, relationships of dependency, although mutually constitutive of each party, are uneven and unequal in subtle distinction to interdependency and often demand sacrifice and heterogeneous symbiosis while refusing symmetrical participation or reciprocal payout. These dependencies are synthesized through particular material encounters coalesced across time, in which boundaries are continuously generated, upheld, tested, and potentially transformed into thresholds for other relations and exchanges, as well as closures and withdrawals. To unveil such an investment from within the fields of contemporary art and architecture, which have both been privileging durational, performative, and relational practices, is to emphasize the means by which such dependencies are rendered visible and legible across time. As ongoing processes and presentations, these art and architectural practices are capable of unearthing various unequal infrastructural alliances from cells to systems, situating but also decentralizing our own living bodies within such alliances while renewing and revising dependent relations between living and nonliving material of all scales. The effect of decentralizing living bodies while simultaneously realigning living and nonliving matter is of course destabilizing and upends any surety viewers and participants might have in determining how and why each of us is living in relation to other bodies and materials both internal and external to our own human systems. And yet, as we will see with each project, we are called to spend time with such uneasiness, caught within encounters that challenge us to redefine not only our own bodily limits but also the limits of living form and time.

Across the book, each chapter pairs a specific branch of contemporary biological inquiry, its laboratory practices and biotechnological implementations with a particular set of artists and architects who enlist, reconfigure, and recontextualize the materials and methods of that biological field of study. Along with these pairings, each chapter

also considers a specific process across art, architecture, and biology that is a crucial step within the forming of life, from synthesizing and maintaining to contextualizing, systematizing, and ultimately regenerating; together, these processes condition and catalyze, sustain as well as reroute material relations of vital dependency. The following five chapters, then, trace a trajectory from the generation and emergence of living matter in specific time frames to the renewal and re-emergence of life-forms within revisionary temporalities—a narrative that begins with the rise in synthetic biology's wider legibility and influence and ends with the worldwide controversy over a hopeful and subsequently failed stem cell technology, both bookends occurring in the last handful of years.

Through such a trajectory, I approach each of the biological and biotechnological processes, and corresponding art and architectural projects, from within a framework of performance theory, aspiring to engage with the wider cultural situations within which all of these practices collide. Performance theory attends to continuous and unfinished situations, emphasizing presentation over representation while exposing the very material conditions that make any object, action, or event possible. With this methodology in tow, I am constantly reminded that the contexts surrounding the art, architecture, biology, and technology remain openly variable, vulnerable, and in progress. I am also reminded that while performance theory inevitably implicates our very human bodies and temporalities, we must also find ways to acknowledge the ongoing histories of other nonhuman living and nonliving things as we enact a materially focused platform for navigating the disciplinary convergences and divergences between art, architecture, biology, and biotechnology. In doing so, I attempt to stand with or according to each art, architectural, and biological project in its own time, while also noting the blind spots that emerge as disciplinary as well as material formations come together, displacing and replacing our bodies alongside other living and nonliving formations and temporalities. Across all the chapters, I emphasize processes in the making, in and across time—processes that lead to the formation of both

material and immaterial dependencies necessary for the synthesis to the renewal of life.

The first chapter, "Vital Synthesis," examines intersections between synthetic biology, art, and design. Linking molecular biology and engineering, synthetic biology modifies and programs living matter, manipulating the building of life from the bottom up as well as isolating and manufacturing particular biological parts for particular applications and outcomes within specific time frames. Answering a curatorial call for a 2013 exhibition at Ars Electronica on the futures and impacts of synthetic biology, a group of artists and designers offered "Blueprints for the Unknown." Their fictional scenarios enact potential events and materialize possible organisms that may already be prefigured in our present moment and thus are imminently forthcoming. By speculating on the larger contexts and consequences of synthetic micromanipulations, these blueprints negotiate between the directed development of bioengineered living forms and the indeterminate situations and relations through which such life subsists in time.

In the second chapter, "Vital Maintenance," I consider the practices and systems that sustain bioengineered life over time by exploring Oron Catts and Ionat Zurr's Tissue Culture and Art Project. Engaging in the practice of tissue engineering, Catts and Zurr culture cell lines and seed them onto polymer scaffolds, coaxing the cells to grow into three-dimensional tissues within temperature-steady bioreactors. In exhibiting these living forms, the artists initiate a series of feeding rituals during which they replace the nutrient solutions required for tissue growth, making visible the nurturing and maintenance procedures performed routinely in labs. To counter their performances of feeding, a killing ritual oftentimes takes place. The bioreactors are turned off, and the audience is left to witness and participate in the disposal of the material life dying inside. Across their arts practice, Catts and Zurr frame the contingencies of forming life through the persistence of care. As an ongoing and variable labor, care unfolds plastic infrastructures that continuously uphold living, semiliving,

and dying forms with and against each other within uneven and changeable material affinities.

The third chapter, "Vital Contexts," calls attention to the dynamic attachments and reciprocities that constantly develop between living forms and their adaptable, flexible, and forceful surrounding environments across time. On a microlevel, all cells anchor onto the scaffolding of an extracellular matrix (or ECM) that in turn acts as a structural support, allowing cells to migrate toward and away from each other, interacting and connecting to form tissues. A healthy ECM is flexible, able to restructure itself while continuing to regulate cell and tissue development, differentiation, and long-term maintenance. In 2006, Jenny Sabin, an architect, and Peter Lloyd Jones, a molecular biologist, formed Sabin+Jones LabStudio at the University of Pennsylvania to visualize and fabricate structural systems in cell biology and architecture according to how variations in form are tethered to fluctuations in the external environment. In tandem with their exploration of the continuous exchanges between cells and their ECM as these interactions influence cell networking, motility, and tissue growth, LabStudio produces scale models at the macrolevel, situating the formation, transformation, and deformation of architectural structures within a similar feedback loop between mutable form and environment.

"Vital Ecologies," the fourth chapter, attends to the inextricably linked boundaries and variable symbioses between organic to synthetic, living to nonliving matter, within and then beyond the context of systems biology. In systems biology, we turn away from the distinct identification and labeling of things and toward the mutual cooperations and sacrifices through which interconnected entities emerge and eventually evolve over time. Against such a backdrop, I explore Rachel Armstrong's protocell architecture, in which cell-like entities without the regulatory system of DNA are manipulated to alter not only micromatter but also macroforms in their environment, remodeling and repairing already existing structures. I then turn to Philip Beesley who creates geotextiles and kinetic architectures of networked surfaces, trellises, and meshes, each constructed with living and nonliving materials that respond to system-wide fluctuations. Across both

practices, whether initiated by human directive or open to other materially led unfoldings, ecologies of self-sufficiency are offered, tested, and transformed, toward an intertwined evolution of living and nonliving forms that acknowledges nonlife as integral to the generation and maintenance of life.

Finally in the last chapter, "Vital Regeneration," I address developments in regenerative medicine and stem cell research, marking major shifts from the 1998 culturing of the first human embryonic stem cell line, to the 2007 advent of induced pluripotent stem cells (iPS) that revert adult human cells back to their embryonic state, and lastly to the 2014 controversy over stimulus-triggered acquisition of pluripotency (STAP), where pluripotency articulates the seemingly boundless ability of embryonic stem cells to develop into any living cell, tissue, and organ. I align these shifts with, between, and beyond Patricia Piccinini's *Still Life with Stem Cells* (2002), which envisages future familial relations in the early days of stem cell science's alliance with in vitro fertilization, and Guy Ben-Ary and Kirsten Hudson's *In Potentia* (2012), a work that reverse engineers foreskin cells back into embryonic stem cells and then onto neurons using iPS technologies. Both projects confront the stem cell promise to endlessly regenerate life within the remarkable instantiation of reversible nonlinear time, while also postulating on the larger ramifications of our ability to continuously reform life within a seemingly renewable future. Within both the capaciousness and limitations of this potentiality, and whether as biologist, artist, architect, or participant, we find unforeseen moments, infrastructures, and correlations upon which formations of life depend, however indeterminately, conditionally, and without assurance.

VITAL SYNTHESIS

Art, Design, and Synthetic Biology

Dear Humanity,

We have to talk.

Let's just say that our relationship has been a bit challenging lately. We've had some ups and downs for sure, the ups of global temperatures and carbon in the atmosphere, and the downs such as the variety of species still sharing our planet.

As you know, I'm a bit concerned about our future. Take this whole area of synthetic biology for example. You say that you understand, that you care, but just because you've sequenced a few bits and pieces doesn't mean you can read me like an open book. Sometimes it feels like I'm just another one of your machines. Is that it? Do you just want to engineer me?

These "synthetic" organisms you're playing with, what are they going to be when they grow up? A bit of give and take wouldn't hurt sometimes, not always you you you. My clock is ticking and I really need some commitment from you, what's your long term plan? Do you even have one?

Yours Synthetically,
Life on Earth[1]

Written as a call to artists, scientists, designers, biologists, biohackers, students, academics, professors, technologists, and futurists alike, this letter was a provocation by Studiolab, a European initiative begun in 2011 to merge the art studio with the scientific research lab. The letter

also provided the initial curatorial framework for a large-scale exhibition of art, design, and synthetic biology that opened in August 2013 at the Ars Electronica Center in Linz, Austria.

Although eventually renamed *Project Genesis*, the exhibition was initially titled *Yours Synthetically*, a twist on a letter's conventional sign-off, "Yours Sincerely." In moving from *Yours Synthetically* to *Project Genesis*, the titling of the exhibition tellingly shuttles between two poles that frame synthetic biology's modes of both generating and altering life. At first glance, the format of a letter calls attention to bioengineering practices of reading and writing, cutting and pasting genetic matter—practices that are becoming easier, faster, and more affordable, with growing numbers of DIY-biologists on board. Yet in light of its subject matter, which acts as an artistic and curatorial prompt, the letter also challenges the overly predictive reading and writing paradigm of molecular biology's "central dogma"; formative to synthetic biology, this dogma states that genetic information in DNA is transcribed by RNA and translated into proteins, which are the building blocks of life.[2] In considering such a dogma with an eye toward its wider repercussions, however, *Project Genesis* curator Matthew Gardiner asks: "But how can a synthetic biologist or engineer know what the impact of this very long sequence [of DNA] can have on the organism, on the whole environment?"[3] Thus, the exhibition's newer emphasis on genesis examines the dynamic emergence of life, in which human-directed generation is haunted with unpredictability.

So as we are becoming more attuned to synthetic biology's specifically targeted modulations of living matter, we must also consider the indeterminacies of such life-forms over time. Following upon a long line of biotechnological manipulations beginning with cell culturing, synthetic biology's engineered manipulation of living matter has complicated how and what we determine as life, as the boundaries between living and nonliving, natural and artificial, organic and inorganic are becoming increasingly convoluted. We still cannot know how these conflations and manipulations will fare, affect each other, or evolve in variable contexts, through multiple encounters and exchanges on micro- to macrolevels, across longer periods of time. As synthetic biol-

ogy continues to catalyze, modify, and redirect life at will, we are left with the speculative lives of these engineered forms and the unknowable dependencies and uncertain contexts through which such modified life is synthesized, entwined, and carried forth in time. While synthetic biology focuses on the particularities of each micromanipulation within a specific time frame, art and design can materialize wider temporal reverberations, framing and reframing the conditions into which life-forms and scales emerge, from molecule to human, synthetic to organic, now and into multiple futures.

SYNTHETIC BIOLOGY AND ENGINEERED LIFE

Coined by Stéphane Leduc in his 1912 *La biologie synthétique* to delineate a physiochemical materialist basis for life, synthetic biology modifies living matter and manipulates the building of life from the bottom up. Combining genetic engineering techniques with new circuit designs in order to design small biological modules with targeted and controllable behaviors, synthetic biology generates cells and minimal organisms that are streamlined for specific tasks; these modules are projected as the model of functional predictability since they can be fabricated to thrive within very specific conditions.[4] Cultural anthropologist Sophia Roosth argues that these acts of biological building foster biological knowing, since such practices explore both what qualifies as life and how life emerges at its most minimal state.[5] To that end, since 2006 the BioBricks Foundation has been seeking to make these standardized biological units, with DNA sequences of particular structure and function, publicly available and freely usable. With easier access to these modified and modifiable parts, researchers are granted more control to design, manufacture, and instrumentalize living matter toward particular applications and outcomes.

In response to such developments, convergences between synthetic biology, art, and design have recently started to materialize. A handful of experiments are now seeking to catalyze and reconfigure living forms on cellular and subcellular levels with these programmable biological parts but in contexts and time frames that are wide ranging

and with outcomes that are far from knowable in advance. For example, in December 2010, Stanford and Edinburgh universities launched a substantial multiyear transdisciplinary research project exploring how collaboratively developed objects, structures, practices, and systems could equally inform the developing field of synthetic biology as well as the contemporary practices of art and design. An artist, Sissel Tolaas, and a synthetic biologist, Christina Agapakis, are examining the smell of microbial communities, and making cheese from human bacteria, in an attempt to expand our tolerance of bacterial cultures on our bodies and in our environments. An architect, David Benjamin, and a synthetic biologist, Fernan Federici, are investigating new ways of using biological systems as design tools by activating cells as bioprocessors, capable of self-generating architectural forms. An artist, Oron Catts, and a synthetic biologist, Hideo Iwasaki, are working with cyanobacterium as a model organism in order to explore different ways of manipulating the bacteria's biological clock and pattern formations. A musician, Chris Chafe, and a synthetic biologist, Mariana Leguia, are considering the oscillation of microfluids in the construction of new and existing sounds. An artist, Sascha Pohflepp, and a synthetic biologist, Sheref Mansy, are trying to construct a lifelike machine from laboratory-built cells, testing the boundaries between artificial and living matter. An industrial designer, Will Carey, and a synthetic biologist, Wendell Lim, are exploring biological mechanisms that may have useful applications in product developments across medicine, agriculture, and energy.

For Alexandra Daisy Ginsberg, the artist-designer who coordinated *Synthetic Aesthetics*, these kinds of ongoing projects warrant a new synthetic branch of the tree of life (Figure 2). Comprising her fourth hypothetical kingdom, "Synthetica," bioengineered and modified living forms demonstrate the capacity to evolve into completely new living organisms with efficiently designed functional capabilities:

> From DIY hacked bacteria to entirely artificial, corporate life-forms, engineered life will compute, produce energy, clean up pollution, make self-healing materials, kill pathogens and even do the housework. Manufacturers will transcend biomimicry, engineering

bacteria to secrete keratin for sustainable vacuum cleaner casings; synthesize biodegradable gaskets from abalone shell proteins and fill photocopier toner cartridges with photosensitive E. coli.[6]

Ginsberg's new imagined branch of life speaks to synthetic biology's self-proclaimed innovative and utopian possibilities while also negotiating between the increasingly obscure delineations of the natural and the engineered—delineations already blurred from the moment cell and tissue culturing paved the way for minute to broad biological modifications. Her synthetic kingdom does not merely validate or enforce a separation between the biological and the biodesigned but rather, as she argues, "puts our designs back into the complexity of nature, lessening the distinction between 'our things' and 'our selves.' Acknowledging this connection between nature and what we design may allow us to design 'better.'"[7] This compels us to ask: What would

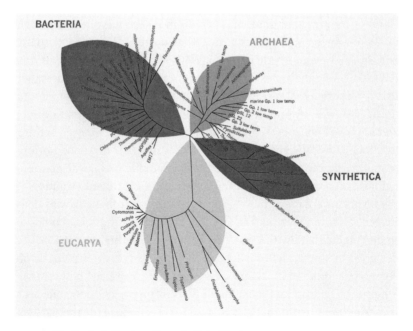

FIGURE 2. *The Synthetic Kingdom*, Alexandra Daisy Ginsberg, 2009. Courtesy of Alexandra Daisy Ginsberg.

designing better entail and, more importantly, how would a better design fare when it is incorporated into an already complex and hybridized biological world?

During her time spent conducting ethnographic fieldwork in synthetic biology labs, Sophia Roosth began to understand that for synthetic biologists, design can mean two things: "improving upon natural selection by 'rationally' engineering living things in a goal-oriented manner" and/or acting as "objects and agents of evolution."[8] Yet in their a quest to "make life better" (the mission of MIT's Synthetic Biology Working Group), many researchers are quick to distance themselves from efforts to create life; indeed, as Roosth discovers, using the word *create* is met with certain distain, while *construct* or *generate* is preferred.[9] For the artists Oron Catts and Ionat Zurr, the question of designing better, whether as synthetic biologist or biodesigner, already bypasses a fundamental problematic: the prominence of synthetic biology's engineering mindset within contemporary biology. "The central claim of the single engineering paradigm is that it is the application of *real* engineering logic onto life," they write. "This is particularly true in the case of synthetic biology. Its rhetoric proclaims that it is not merely rebranding existing forms of manipulating life, but rather that it represents a far-reaching shift in the way life is perceived and used."[10] Now living matter is at the service of us humans to direct and improve upon, always toward identifiable goals. But these attempts to direct or improve life oftentimes disregard the unintended or potentially unmonitored fallouts of these synthetic biological manipulations and projections over time, beyond the controlled evolution of life-forms toward predictable outcomes. Even as synthetic biology does indeed seem to focus on constructing and generating life in order to understand it better, the question remains: whether or not a better designed life-form, that is catalyzed by humans and evolutionarily directed to be more rational and comprehensible, is indeed better in the long run? The implication is that in the short term synthetic biology's prescription of living matter and systems points toward very particular results, while the problem is that we cannot imagine the impact of

such synthetic matter and form in relation to other living forms and as incorporated into all manner of hybridized systems into the future.

SPECULATIVE BLUEPRINTS

This is the very lament launched by the letter written to "Humanity" from "Life on Earth." Answering the call, a group of artists and designers offer "Blueprints for the Unknown": sketches, diagrams, plans, and scenarios that are meant to lay the groundwork for predetermined end goals conceived by synthetic biology but instead afford the possibility of indeterminate, ongoing, and variable outcomes. By imagining, materializing, and then documenting potential scenarios and soon-to-be organisms, bodies, events, and actions, these blueprints perform the untenable relationship between the promise of predictable engineered life and the unpredictable contexts from which and into which such forms of life prevail over time. While the *Project Genesis* exhibition at Ars Electronica included eighteen projects from artists around the world who engage with synthetic biology, I want to call attention to the three works developed specifically under the umbrella of "Blueprints for the Unknown"—all three of which problematize the futurity of human-led synthetic modifications by setting the stage for various unintended outcomes. Each project is exhibited as if the scenario had already happened, with documentary evidence presented as fact and gathered data and paraphernalia displayed as if already in use.

With specimens, maps, and photos, Tobias Revell's *Into Your Hands Are They Delivered* tells us this story (Figure 3):

> Deep in the Texan swamps, a new species of parasitic wasp is discovered by the T-SEE expedition who are funded by the crumbling Richards-Jones Institution and buried in its extensive collection of insect specimens. Years later, Global Petroleum, the nation's largest petroleum company working in the Gulf of Mexico suffers from blockages in its pipeline network. To their horror, Global Petroleum scientists discover that a new species of parasitic wasp is incubating its eggs in the petrochemicals the company

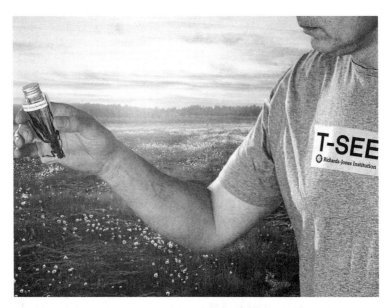

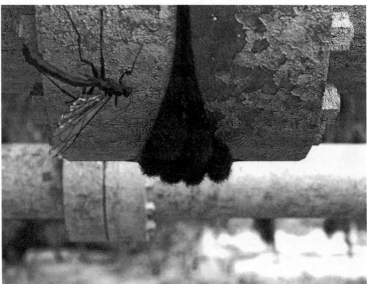

FIGURE 3. *Into Your Hands Are They Delivered,* Tobias Revell, 2013. Courtesy of Tobias Revell.

manufactures and distributes. It becomes clear that the wasp discovered by T-SEE has evolved rapidly to develop a parasitic relationship with synthetic chemicals.[11]

Envisaging a future in which wasps and oil are inextricably intertwined as a new species that has evolved to feed on synthetically modified petrol, the project borrows its name from a biblical passage in Genesis in which God relinquishes his control over life on earth and grants dominion to humans.

> And God blessed Noah and his sons, and said unto them, Be fruitful, and multiply, and replenish the earth. And the fear of you and the dread of you shall be upon every beast of the earth, and upon every fowl of the air, upon all that moveth upon the earth, and upon all the fishes of the sea; into your hand are they delivered.[12]

The reference to this part of the Bible harkens back to one of the earliest bioartworks by Eduardo Kac, who also quoted a similar passage in his own *Genesis* (1998/1999).[13] Kac translated the passage into Morse code and translated the Morse code into DNA base pairs and then finally genetic sequences, which he implanted into bacteria. He placed the genetically altered bacteria in a petri dish under ultraviolet light, which in-person and online viewers could activate. If the viewer disagreed with allowing humans to have dominion over nature as the quote from the Bible suggests, then in order to destroy the idea, she could turn on the UV light, which would cause mutations in the genes thereby altering the statement; but in doing so, she would also be asserting her own power over nature. While in Kac's piece human dominion is enacted as opposed to the staging of such power in Revell's project, in both works life on earth becomes increasingly mutated while under the care of us humans. For Revell, these manipulations have the potential to incur the unexpected evolution of completely new forms of entangled life, in this case the very livelihood of a species that depends on our synthetic modification of petrochemicals and, over time, on its economic flow and global distribution (Figure 4).

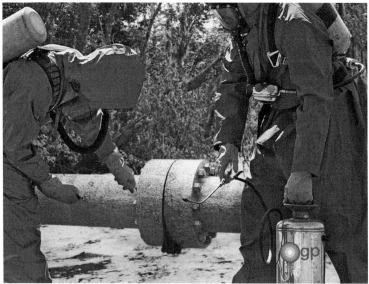

FIGURE 4. *Into Your Hands Are They Delivered*, Tobias Revell, 2013. Courtesy of Tobias Revell.

In another future "Blueprints for the Unknown" scenario staged by the group Superflux, *Dynamic Genetics vs. Mann* offers material evidence gathered from a fictional court case. An interrogation video, surveillance photos, genetic search warrants, found documents, newspaper clippings, an improvised CO_2 incubator, and tissue biopsy samples piece together the story of Arnold Mann, an ordinary citizen (Figure 5a). When a routine spit test shows elevated risks for various chronic health conditions, Mann is forced to get a gene upgrade on the black market in order to avoid huge health insurance bills. Dynamic Genetics is the gene therapy corporation that accuses Mann of possessing their DNA as a result of his illegal procedure (Figures 5b and 5c).[14] Transporting synthetic biology and gene therapy to the health insurance marketplace, Superflux manifests a world in which health plans are determined by an individual's genetic make-up and where remedies and therapies are available only to a new class of the genetically elite (Figure 5d). Discussing the project, synthetic biologist Christina Agapakis suggests that Superflux's future imaginings "show technologies at the edge of speculation and reality, inviting us to imagine, question, and debate the applications and implications of new science and technology in a cultural context."[15] Materializing as well as interrogating this potential future outside of the lab, *Dynamic Genetics vs. Mann* enacts one possible outcome of the enduring hope that our genetic codes can predict our future health, now translated into our need to genetically oversee and manage ourselves as well as others.

With small test rigs and experiments, a flag and a manifesto, David Benqué orchestrates the operations of a new kind of future personae. The New Weathermen is a group of environmental activists who embrace "a new symbiotic world order" between the synthetic and organic, already increasingly blurred (Figure 6a). In their manifesto printed in the group's cookbook (a follow-it-yourself set of directives for action), the weathermen set forth a series of principles and ground rules celebrating synthetic biology's uninhibited expansion and the freely applied modification of living matter, forms, and bodies (Figure 6b):

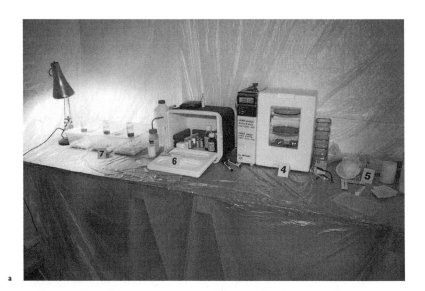

a

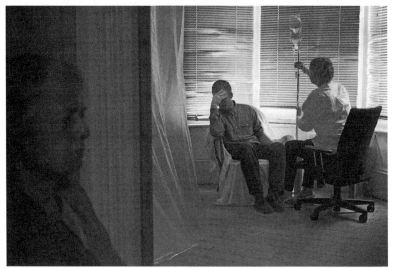

b

FIGURE 5. *Dynamic Genetics vs. Mann*, Superflux, 2013.
Courtesy of Superflux.

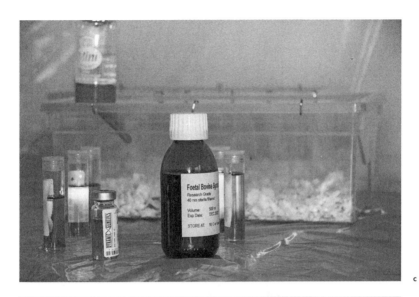

c

d

a

FIGURE 6. *The New Weathermen,* David Benqué, 2013. Courtesy of David Benqué.

b

Parasite Lost: Parasitic behaviour will not be tolerated

Eden Gone: There is no untouched Nature to go back to. Only forward

Caution is for Preys: Abort the precautionary principle

Bio Commons: Abolish intellectual property

Species Galore: Conserve all species and genomes. Create as many new ones as possible.[16]

Following such a paradigm, a selection of highly ambiguous Weathermen activities include: #PIRATE POLLEN CLUB, a wind dispersion tunnel that activates copyrighted gene removal in proprietary golf-course grasses; #palmops #BIOLULUZ, a Palm Oil Non-Digester, in which lipase inhibitors prevent palm oil from being digested; and finally #BIOCCUPY DIESEL, a Diesel Bug Test Rig, which catalyzes the optimization of microbial contaminations in diesel fuel tanks (Figure 7). Recalling

FIGURE 7. *The New Weathermen,* David Benqué, 2013. Photograph by Kristof Vrancken/Z33. Courtesy of David Benqué.

situationist tactics of disturbance combined with a growing DIY biology sensibility, such objects and actions synthetically modify random materials in particular sites, catalyzing scenarios in which surprise synthetic interventions are ridiculously interruptive. Activism here is afforded by our increasingly easy ability to micromanipulate any existing living matter—across our golf courses, our intestines, our gas tanks, and beyond—all for dubious gains.

AFFIRMATIVE DESIGN SPECULATIONS

These three very different scenarios staged by Revell, Superflux, and Benqué are all speculative; they each project a possible future already embedded in and potentially always ready to become our present. As a part of Ars Electronica's annual art and technology exhibition, all three works were developed in the Design Interactions program at the Royal College of Arts in London, a particular kind of program that joins design with speculation. Indeed, speculative design, as proposed by Anthony Dunne and Fiona Raby, founders of Design Interactions, is a new field that emphasizes critical and oftentimes radical propositions for life as it could be. While the capacity for designers to imagine new worlds and lives is alluring, we must also recognize that unfolding alongside speculative design's promise to envision the world otherwise can be a very uncritical erasure of embodied particularities within these futuristic and oftentimes generalized narratives, as evidenced by a recent debate on the forgotten dimensions of race and gender generated on MOMA's online discussion board on "Design and Violence."[17] In fact, Christina Cogdell argues that the promised critique of biotechnological developments is still more often instigated by "bioartists [who] seem more willing than biodesigners to discuss the ethics of domination and exploitation that inhere to the trend of the 'biologicalisation of our world.'"[18] Yet as biodesign, speculative design could instead present other expanded contexts and temporal unfoldings as conjecture, in refusing to deliver useful product developments as most designs inevitably do and with additional careful attention to the specificities of both existing and imagined bodies. In doing so, specula-

tively designed objects and events have the capacity to question rather than confirm how and why designers introduce and modify things in the world for specific kinds of users and across particular time frames.

Speaking about the role of critical design in relation to the growing expansion of synthetic biology, David Benqué suggests: "Design as an efficient problem solving process is turned into an exploratory problem finding tool, a way to pre-enact synthetic biology moving out of the sanitised bubble of the lab and into the complex systems of society."[19] Pre-enacting in larger contexts over time offers the potential to launch questions without promised answers, to afford ambiguity in the place of certainty, and to do so over wider sites and longer scales of time. Instead of producing objects to be used, as Dunne and Raby remind us, "the idea of the proposal is at the heart of this approach to design: to propose, to suggest, to offer something. . . . To be effective, the work needs to contain contradictions and cognitive glitches. Rather than offering an easy way forward, it highlights dilemmas and trade-offs between imperfect alternatives."[20] As such a mode of design becomes increasingly unattached to functional use-value and end results, its proposals find common ground with all manner of imaginative fiction, whether utopic or dystopic, scientifically plausible or not. Such practices of fictional speculating can at the very least propose an awareness of the variable contingencies of time and scale, of the unpredictability of encounters and exchanges between the living materials and forms continuing to emerge and evolve around us, and of the incalculable nuances of their developing relations into the future.

This kind of open-ended speculation is, however, at odds with our historically modern mode of firmative speculation; I am speaking here most generally about the act of speculating as conjecture, as imagining a future that has not yet materialized, including both the intended and unintended repercussions of that speculative act. For an anonymous collective of theorists writing contemporaneously under the name of "uncertain commons," modernity broadly introduced this act of speculation as a "mode that seeks to pin down, delimit, constrain, and enclose—to make things definitive, firm."[21] So modern speculation produced statistical calculations that give a probable account of

what might happen in our present-day world—economically, environ-
mentally, politically, biologically, medically—in order to manage the
risk associated with the unknown world-to-be by producing one po-
tential outcome, exploiting it, and foreclosing all other possibilities.
In line with the fictional propositions offered as "Blueprints for the
Unknown," the uncertain commons propose an alternative mode of
speculation—the affirmative—that instead celebrates the indetermi-
nate. Affirmative speculation undoes anticipatory solutions, embraces
the unthinkable and the unquantifiable, takes rather than manages
risks, and opens up a multitude of worlds-to-be, not just for one but
for many other things and beings, human and nonhuman, now and
into the future. Investing in the unknowable futurity inherent in any
act of speculating, as well as underscoring the uncertainty through
which any collective commons comes together, they write:

> To speculate affirmatively is to produce futures while refusing the
> foreclosure of potentialities, to hold on to the spectrum of possibili-
> ties while remaining open to multiple futures whose context of
> actualization can never be fully anticipated. This is not to say specu-
> lative living is simply ephemeral; rather, it is a consistently modify-
> ing practice that seeks to act in shifting, multiscalar worlds. . . . Its
> stakes are resolutely collective: often sabotaging individuated and
> privatized prescriptions, it builds on the tentative mutualities that
> arise in the face of uncertainties.[22]

In affirmative speculation's contingent latency, then, is both a thinking-
other and a doing-otherwise, always with and for another. In such a
spirit, it is important to contend with each of the potential futures sug-
gested by Revell, Superflux, and Benqué not as ominous threats to be
quelled and contained, as modern firmative speculation would have
it, but rather as one of many potentialities unfolding simultaneously
and momentarily brought together in one exhibition. We could then
experience each scenario as one of many possibilities actualized in
order to situate possible dependencies between organic and synthetic
forms over time, within and across all three of the proposed contexts,
provoking and multiplying others yet to come—including and beyond

wasps dependent on crude oil, humans dependent on a genetically determined health-care system, and environmental activists taking over fuel tanks. With such numerous imaginings materialized at once before us, we could then attempt to follow the call set forth by the uncertain commons to "venture out on the ledge, looking into and touching the abyss that unsettles in full realization of our insufficiency of knowledge."[23]

UNKNOWABLE SYNTHESES

In the world of synthetic biology, we are not only quickly coming closer toward that ledge but stepping into the abyss. As life is being generated and manipulated as raw matter, and as the bodies modified and doing the modifying, we cannot really know what these actions imply, or who or what will be implicated in time, as I have been arguing throughout this chapter. But in its own way, synthetic biology has also been exploring how its discretely engineered modules can be integrated into larger, more complicated, and variable biological systems, where standardization and coordination are more difficult, in order to consider the variable conditions and complex interactions that occur in ever-changing contexts over time. According to Dr. Vivek Mutalik, a researcher at BIOFAB, the first biological design-build facility producing freely available biological parts, "Until now, virtually every project has been a one-off—we haven't figured out how to standardize the genetic parts that are the building blocks of this new field. Researchers produce amazing new parts all the time, but much like trying to use someone else's house key in your own door, it's been difficult to directly reuse parts across projects."[24] Indeed, reuse is the foundational and purposeful basis of synthetic biology, Drew Endy told me.[25] Endy is the codirector of BIOFAB, president of BioBricks, and a pioneer in synthetic biology. As Endy and his colleague Alistair Elfick, codirector of the SynthSys Centre at the University of Edinburgh, have postulated: "How do we achieve reliable performance in a device when there is the likelihood of it spontaneously mutating away from its designated function?"[26] In fact, in order to determine the functional patterns of

genetic parts in variable circumstances, researchers have to understand how they misbehave when reused again and again in different ways. With the real possibility of mutation over time, the challenge for synthetic biologists, then, is to develop keys that will fit into and open many doors in many different contexts. Making headway toward that end, BIOFAB researchers have been able to determine a precise grammar or the rules by which certain standardized parts of DNA fit together. Although the DNA parts are specific for *E. coli*, the most widely used model bacterium, the grammatical rules could potentially apply to other microbes as well.[27]

And so the reading and writing genetics paradigm continues, as invoked and then questioned by Studiolab's letter as curatorial call. We have the words and we have certain grammatical rules for how some of these words will fit together. In this world of synthetic biology, then, we could say that performativity is central; each word, or discrete unit or sequence, is meant to enact a particular function in a particular situation, its work being iterative. But we still cannot prescribe the reusable intentions of these parts and systems in the long run or the implications in wider macrocontexts. Give these parts to multiple forms, scale them up in a multitude of settings, and iteration can be foiled and displaced, as we learned from J. L. Austin's delineation of "infelicities" within his speech act theory. According to Austin, performative utterances—or statements that enact something as they are being uttered (the "I do" of a marriage is the most cited example)—can be and can go wrong. These "infelicities" occur when a performative utterance, the force of which stems from engrained repetition over time, misfires and its act becomes void or, alternatively, when such an utterance is abused and its professed act is hollow.[28] For Austin, "happy performatives" occur when all parties involved have similar expectations for initiating and accepting the utterance as action, in each and every one of its iterations over time.[29] But the multiple bodies and contexts within which these speech acts occur are of course variable; each situation and its temporal unfolding presents an opportunity for a performative utterance to fail, its intended action misdirected or empty.

In concert with performativity, then, performance can refer to the variability of these iterations and actions unfolding across time and scale, to the slipperiness of performativity's promise to enact this/now, again and again, and to the incongruous and ongoing outcomes of any functional blueprint. Performance theorist Peggy Phelan writes: "In moving from the grammar of words to the grammar of the body, one moves from the realm of metaphor to the realm of metonymy."[30] For Phelan, bodies in performance are metonymic because they signal what she calls an "axis of contiguity and displacement."[31] Instead of promising iterative repetition with predictable outcomes, bodies deflect and displace their reproducibility, unsettling any clear determination of replicable grammar in the context and temporal unfolding of embodied action.[32] If, even for a moment, we could gesture toward Phelan's claims without specifically holding onto the human body in performance, then we might align both human and nonhuman forms, as well as organic to synthetic matter, as together performing along this metonymic axis. In action and in relation to each other, living matter, forms, and bodies would all resist stable definition, performative replicability, and predictability over time, instead tending toward the uncertain and indeterminate in each specific situation and in relation to each other. To move from the performativity of living matter toward its performance is to reinvest living forms with contextual variabilities, potential macroembodiments and relational dependencies across all scales—indeed, to inflect synthetic biology's micromodulations with the affirmative speculative conditions of life's unknowability over time. And, to bring us back to the projects that opened this chapter, this move from the performative to the performance of living matter translates synthetic biology's prescriptive words into the forms and renders its grammar onto the bodies, both human and nonhuman, of "yours synthetically, Life on Earth." Moving from performativity to performance, we begin to acknowledge the ongoing synthesis of things and beings over time and across a variety of forms and scales, organic to synthetic, micro to macro; we then can speculate on the welcome and unwelcome acts, events, and relations that reside as contingent latencies in these uncertainly unfolding lives.

To modify and design matter in this way would mean taking multiple longer and wider views of the eventual forms that will enter into and then act upon the world, as the "Blueprints for the Unknown" projects have staged for us. Realistically on-the-horizon, cautionary or parodic, Revell's, Superflux's, and Benqué's scenarios signal the problem of knowable futurity that is embedded in both the instrumentality of life itself in its microperspective and the indeterminacy of vitality in its endless emergence. We come to realize that if we only focus on what we can do now to life, on a microscale, we will have no idea what is going to happen in the future, on a macroscale. But if we know we are going to have parasitic wasps living in pipelines with biochemistry similar to crude oil, or a health-care marketplace of individual gene markers and therapies, I find myself wondering: Would we initiate random and disruptive yet ultimately futile interventions in line with the New Weathermen? Would we identify and then take preventative measures, and how, and how many? This line of questioning quickly begins to spin out of control. By materializing the future as already here, these projects are each speculating upon an unknown, predicting an unpredictable, and determining an indeterminate, but one out of many. We can take them as warnings to be pre-emptively foreclosed. Or, as I would rather propose, we can recognize that as we put things into and change things within the world, we and they never act discretely and never only in one way; encounters and exchanges within multiple contexts unfold across time into vital conditions for the generation, maintenance, and re-emergence of life. We cannot lay claims to this unknown; what we need are more blueprints, more open-ended explorations whether materialized or imagined, and more convergences between artists, designers, and synthetic biologists.

In turn, we would do well to keep an expansively questioning and speculative design mindset in play as we witness the arrival of more synthetically manipulated objects, formats, structures, and systems as a widespread, more often than not utopic, biodesign fervor takes hold of our popular culture and imagination.[33] Across variations in the qualification, formulation, and modification of life, and between the organic and inorganic, synthetic biology catalyzes a series of inter-

actions and relations, activating processes that simplify, rationalize, and scale life up and down in ways that ultimately cannot be fully directed or predicted over time. Throughout these processes, interventions into living forms and systems must acknowledge the contingencies that propel those very modulations of biological life. These are the contingencies of contact, of encounter, of matter and bodies standing next to and inside, of holding and housing, one scale of life alongside and within another. These are also the contingencies of boundary relations, exchanges, and dependencies, whose revisable terms and impacts must be encountered, again and again, with caution and care. So, as we begin to materialize new forms of life and continue to manipulate that life across time, what kinds of dependencies will persist, what mutualities compromised, what entanglements recalibrated? We have to ask these kinds of questions because throughout all of these ongoing projects, we need to be considering not only why and how but also in what context and for how long you, I, this, and that are synthesizing, when we synthesize life.

VITAL MAINTENANCE

The Tissue Culture and Art Project and Infrastructures of Care

Biodegradable polymer scaffolds are sterilized in ethylene oxide at 131°F for two hours. These constructs are then seeded with cells from the McCoy cell line, originally derived from fluid in the knee joint of a patient suffering from degenerative arthritis but now classified primarily as mouse endothelial cells. Remaining for three weeks in a carbon dioxide incubator kept at the human body temperature of 98.6°F, the proliferated cells begin to largely cover the polymer surfaces, growing through the porosity of the synthetic scaffold and held together by surgical sutures (Figure 8). The tissues expand to approximately ten millimeters tall by seven millimeters wide within a rotating bioreactor that provides the condition of microgravity so as to encourage three-dimensional growth (Figure 9).

These are tissues cultured and structured outside of a body, fed with a protein-rich serum derived from the blood of fetal calves, and imbued with the care of the researchers who are attempting to coax new living forms into existence; and they are also Oron Catts and Ionat Zurr's Tissue Culture and Art Project, the *Semi-living Worry Dolls,* the first living tissue-engineered sculptures (Figure 10). They were initially presented at Ars Electronica in 2000 and since then have been regrown and re-exhibited multiple times, as recently as the 2011 exhibitions *Synth-ethics* at the Natural History Museum in Vienna and *Visceral: The Living Art Experiment* at the Science Gallery in Dublin, as well as the 2012 exhibition *Crude Life* at both the Laznia Centre

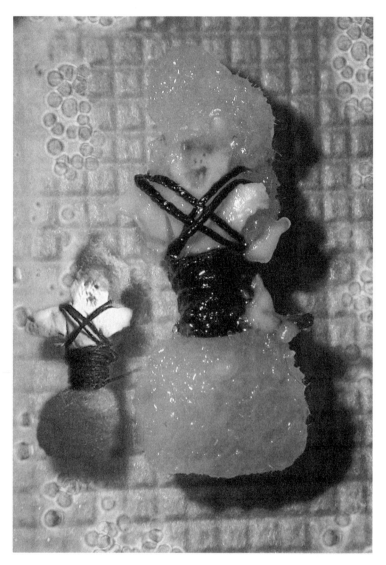

FIGURE 8. *A Semi-living Worry Doll H,* the Tissue Culture
and Art Project, 2000. McCoy cell line, biodegradable/
bioabsorbable polymers, and surgical sutures, 2 x 1.5 x
1 cm. From the *Tissue Culture and Art(ificial) Wombs*
installation, Ars Electronica. Courtesy of the Tissue
Culture and Art Project (Oron Catts and Ionat Zurr).

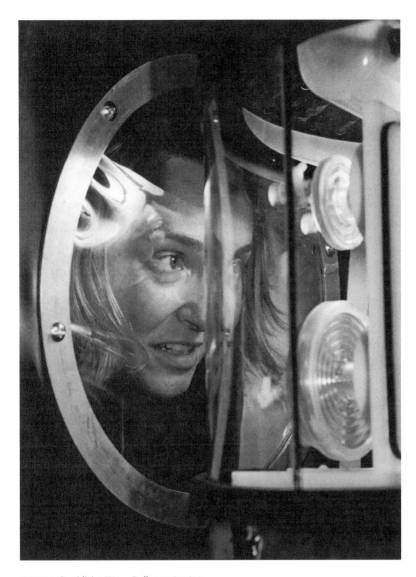

FIGURE 9. *Semi-living Worry Dolls* growing in a
bioreactor, the Tissue Culture and Art Project.
Photograph by Axel Heise. Courtesy of the Tissue
Culture and Art Project (Oron Catts and Ionat Zurr).

of Contemporary Art in Gdańsk, Poland, and the Copernicus Science Centre, Warsaw, Poland.[1] As their structural polymers degrade and their tissues continue to develop, these figures are partially alive versions of the Guatemalan dolls given to children. Like those figurines, Catts and Zurr have also invited viewers to contribute their own worries, first by writing them into a computer guestbook database and later, during the *Visceral* exhibition, by actually whispering them into a microphone, to be amplified and played within the incubator to the dolls-in-growth.[2] Activating symbiotic relationships between living, semiliving, and dying matter, TC&A's practice, including and beyond these worry dolls, attests to the material and labored work, as well as the social and affective networks necessary to sustain vital forms, living and dying over time. While the first chapter called for a wider-ranging temporal attention across the generation and manipulation

FIGURE 10. *Semi-living Worry Display*, the Tissue Culture and Art Project. Courtesy of the Tissue Culture and Art Project (Oron Catts and Ionat Zurr).

of living matter into the future, this chapter specifies what kind of attention is necessary. Catts and Zurr frame the contingencies of forming life in terms of the temporalities of care, directed toward living micromatter that typically go unnoticed and unseen by macroliving entities. Beyond both the autonomy of self-care and the teleology of healing, the processes of sustaining these cells and tissues are ongoing yet oftentimes partial and incomplete. Performed in a gallery setting, the material infrastructures and immaterial procedures integral to the maintenance of living forms together advance a mode of care that acknowledges multiple human and nonhuman dependencies across micro- to macroscales that are consistently revised over time.

TISSUE CULTURE RITUALS

Cofounded by Oron Catts and Ionat Zurr, the Tissue Culture and Art Project has been exploring the use of tissues and tissue technologies as artistic media since 1996, and as of 2000 the project has become a primary component of SymbioticA, the art and science collaborative research laboratory at the University of Western Australia.[3] In Catt and Zurr's words:

> TC&A looks at the level above the cell and below the whole organism, hence at the collective behaviour of cells which forms tissues. We are using tissue engineering and stem-cell technologies to create Semi-Living sculptures. . . . The Semi-Living relies on the vet/mechanic, the farmer/artist or the nurturer/constructor to care for them.[4]

Because tissue constructions like the worry dolls required sterile conditions and a steady temperature as well as a constant supply of nutrient media in order to keep them (semi-)alive, Catts and Zurr have initiated a series of installation and performance rituals that, to this day, continue to frame their exhibition practice and situate themselves as caregivers.[5] The gallery or museum becomes a scientific laboratory, complete with an enclosed area housing a sterile hood, bioreactor, microscopes, nutrients, agents, solutions, petri dishes, pipettes, and all

other manner of lab equipment and safety precautions that will allow the artists to generate their artwork, while viewers are able to witness the developing forms. This art-viewing experience is punctuated by the procedures and protocols necessary for the dolls' sustenance, as technicians (usually Catts and Zurr) clothed in lab coats, gloves, and goggles feed the cells and tissues with fetal bovine serum, the nutrient media necessary to keep them alive.

To complement these feeding rituals, Catts and Zurr began in 2002 to institute a killing ritual at the end of each exhibition. The tissue sculptures are taken out of their incubators, bioreactors, and petri dishes for the audience to touch, exposing the semiliving entities to unsterile conditions. Touching contaminates the cells with the bacteria and fungi on our skin, which causes the cells and tissues to die either instantly or over time. The worry dolls were first killed in public and by touch at the *BioFeel* exhibition at the Perth Institute of Contemporary Arts in August 2002.[6] Subsequently, at the end of the *Visceral* exhibition at the Science Gallery, audience members were invited for a formal funeral service in which they signed a condolence book and gathered to discuss the ethics of this kind of killing. While Catts noted that he already killed far more living matter when he brushed his teeth that morning, nonetheless there was unease surrounding the killing of these dolls, which required the event to be marked, framed, and performed; those who had previously grown, fed, or even just viewed these figures-in-growth were invited.[7] In a 2003 *L'art Biotech* exhibition in Nantes, France, Catts and Zurr used the same type of cells derived from frogs to grow their worry dolls as well as their first in-vitro, tissue-grown "victimless meat" (Figure 11). At the end of that exhibition, they killed the meat by cooking and inviting the audience to eat it (Figure 12), while killing the dolls by inviting the audience to touch them. Consumption, whether by ingestion or by touch, ends the life of both forms of the same growing tissue, and both acts of death are unsettling. The acts unnerve us because we are killing life and, perhaps more significantly, because the tissue-forms are living matter that we do not usually qualify as living beings or endow with the same tangled ethical and phenomenological tenor of macroliving organ-

isms. Therefore, when we find ourselves worrying about these tissues in a similar manner to each other or our pets, especially because we have invested our time in witnessing and participating in their growth over time, our expectations of sustaining life are projected onto these material forms. So the question of what kind of life warrants being sustained bypasses a question of scale to become a consideration of the ways in which we encounter and relate to various material forms over longer periods of time.

At the close of the Biotech for Artists workshop led by Catts at the Biofilia, I was among the group of participants who had to decide how to kill the living matter we had grown over the course of a week. One of my lab partners, the designer David Benqué, came up with the idea of a firing squad technique; three of us would each simultaneously

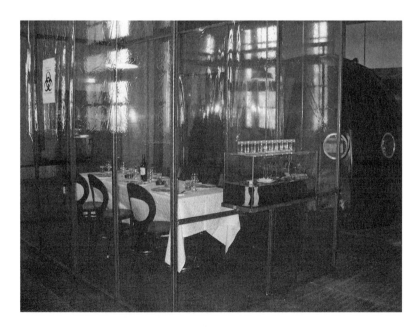

FIGURE 11. *Disembodied Cuisine*, the Tissue Culture and Art Project, Nantes, France, 2003. Photograph by Axel Heise. Courtesy of the Tissue Culture and Art Project (Oron Catts and Ionat Zurr).

FIGURE 12. "Tissue Engineered Steak No. 1," a study for
Disembodied Cuisine, the Tissue Culture and Art Project,
2000. Prenatal sheep skeletal muscle and degradable
PGA polymer scaffold. Courtesy of the Tissue Culture
and Art Project (Oron Catts and Ionat Zurr).

pour an unidentified clear liquid over the life we had nurtured.[8] One
of these liquids was ethanol, which would be our killing agent, and
the others were water; we did not know who was pouring what, and
in doing so, we collectively shared responsibility for the killing, while
leaving individual responsibility unknown. As Catts also told me, in
some cases TC&A has also used chemicals to kill some of their sculp-
tures, and in other cases they were forced to use bleach when the living
matter became contaminated.[9]

Artist-scholar Kelly Rafferty suggests that these rituals of feeding
and killing "draw attention to the fact that the viewer and the semi-
living are spending time together growing, changing, and dying to-
gether."[10] Feeding and killing also significantly project the temporality

of our very human living and dying bodies onto the cells and tissues that, as we have learned, die in multitudes every day in ways we do not usually see and do not usually care about. If we look at some of the worries relayed to the dolls-in-growth, we can see how multiple forms of living matter and bodies are becoming vulnerably intertwined. The anxieties are deeply and sometimes shockingly personal and intimate, as the dolls attend to secret and specific whispered declarations such as: "I worry that I won't be successful. I worry that I won't make other people happy. I worry that I will fall" and "I'm worried I don't love you enough because Hannah and Thomas broke my heart before I could find you" and "I'm afraid I will never get the permission to become myself, so that I could spend my life living and loving," and someone confesses to having an abortion.[11] Tangled and uneasy relationships arise, as TC&A's expanded gallery and durational art practices ask us to give and take time with the human and nonhuman living forms around us, in and out of time with ourselves.

During a ten-day exhibition at the 2002 Adelaide Biennial of Australian Art of their tissue-engineered *Pig Wings,* cultured with stem cells from a pig's bone marrow into tiny pairs of bird wings, bat wings, and dinosaur wings (Figure 13), Catts and Zurr noticed the unfolding phenomenological and affective engagements with their works. At the end of the exhibition, the gallery guards asked to learn how to feed the tissues so that the three living wing sculptures would not have to be killed; in fact, this would be the first time that Catts and Zurr had instituted their killing ritual. Then upon the end of the wings' lives, the director of the biennial, Peter Sellars, began to cry.[12] These oddly constituted and variably scaled conjunctions of tissues and security guards, cells and art directors, are coalesced through Catts and Zurr's performance rituals that mark multiple dependencies necessarily unfolding across the temporal duration of living matter. By making time and spending time together, and by prolonging and suspending the time in which these gatherings may occur, the material forms and times of cells, tissues, artists, performers, viewers, and participants become inextricably entangled within the acts of forming, sustaining, and ending life.

FIGURE 13. *Pig Wings*, the Tissue Culture and
Art Project, 2000–2001. Pig mesenchymal cells
(bone marrow stem cells) and biodegradable/
bioabsorbable polymers (PGA, P4HB), 4 x 2 x 0.5 cm
each. Courtesy of the Tissue Culture and Art Project
(Oron Catts and Ionat Zurr).

INVOKING CARE

As performers and participants publicly engage in the oftentimes illegible and invisible methods of generating and maintaining living matter, the Tissue Culture and Art Project challenges us to determine new modes of caring for multiple scales of life. If, as Catts and Zurr explain, "by the most obvious or 'natural' act of human nurturing, through caressing, we kill communities of cells which are stripped from their host body and immune system," then by extension, should we expand what and who we care for exponentially to encompass all living matter?[13] Or how should we continue to navigate caring for some things and not others? In my mind, these kinds of questions can and should be rerouted from what we care for toward questions of how and, even more specifically, how long do we continue to care. These issues of care across expanded formulations of living matter have always been central to the TC&A's practice, as well as to SymbioticA's ongoing research agenda; in fact, TC&A's very first international symposium took up the subject of "Aesthetics of Care" across human and nonhuman materials and subjects.[14] While both their feeding and killing rituals enact an expanded durational framework that enmeshes micro to macro living and dying forms, such rituals also suggest that all formations of life are developed, sustained, and relinquished through continuously intertwined acts and structures of caregiving, care receiving, and care withdrawal, however uneven or momentary.

Indeed, in a larger sense, the invocation of care has historically been figured as central to the formation of living beings and things in and among the world.[15] Put another way, care constitutes something as a living thing. Perhaps most emphatically, care has been posited as ontologically fundamental to the forming of human beings, as relayed in the ancient Roman creation myth from a second-century Latin collection edited by Hyginus:

> Once when Care was crossing a river, she saw some clay; she thoughtfully took up a piece and began to shape it. While she was meditating on what she had made, Jupiter came by. Care asked him to give it spirit, and this he gladly granted. But when she wanted her name to be bestowed upon it, he forbade this, and demanded

that it be given his named instead. While Care and Jupiter were disputing, Earth arose and desired that her own name be conferred on the creature, since she had furnished it with part of her body. They asked Saturn to be their arbiter, and he made the following decision, which seemed a just one: "Since you, Jupiter, have given its spirit, you shall receive that spirit at its death; and since you, Earth, have given its body, you shall receive its body. But since Care first shaped this creature, she shall possess it as long as it lives. And because there is now a dispute among you as to its name, let it be called *homo*, for it is made out of *humus* (earth).[16]

This is the very myth that the phenomenological philosopher Martin Heidegger quotes, in its totality, in *Being and Time*.[17] Foundational to his thinking, the myth is integral to Heidegger's primary concept of *Dasein*, literally translated as "there-being," and variously interpreted as distinctive to a human mode of being, though the term does not refer specifically to the biological.[18]

Although it is not in the scope of this chapter to elucidate the particularities and complexities of *Dasein*, nor do I wish to strictly adhere to a Heideggerian template for care's potentiality with regard to the exclusively human, I do want to draw attention to the temporal and contingent manner in which this mythic, pre-existent figure of Care determines being, being in the world, and being with other beings and things. As Heidegger goes on to explain: "In care this entity has the 'source' of its Being. . . . The entity is not released from this source but is held fast, dominated by it through and through as long as this entity 'is in the world.'"[19] Conditioned by care rather than coming into being through self-creation and mastery, and sculpted by and belonging to care for the course of life, this way of being is thus vulnerably embodied by the world and with others. This conditional and contingent quality of care in the formation of being is also significantly augmented by temporality, which in turn is reciprocally integral to both the figure and function of care. As Heidegger states: "The preontological characterization of man's essence expressed in this fable, has brought to view in advance the kind of Being which dominates his *temporal sojourn in the world*, and does so through and through."[20]

Indeed, as Stephen Mulhall reminds us: "For, of course, the character in the fable to whose authority even Cura must submit is Saturn; and Saturn is the god of Time. But if the creator of Dasein is herself the servant or creature of Saturn, then the most fundamental characterization of Dasein's Being must invoke not care but that which somehow conditions or determines care—time."[21] While care is thus inextricably tied to the ongoing temporal life of being, it is time that necessarily qualifies and grants care.

However, *Dasein* is a specifically human way of being in the world, and the status of the nonhuman or animal remains outside Heidegger's primary philosophical trajectory. He ambiguously conceptualizes the not-yet-quite or not-quite-fully human in terms of *animalitas,* as opposed to *humanitas,* yet *animalitas* is still in the domain of man.[22] In fact, as Timothy Campbell points out in his reading of the improper in Heideggerian thought: "Despite these gyrations between animal and human, there remains a stark division between the human and another, potentially human, if provided with sufficient care."[23] The rupture, for Heidegger, is between the "properly human" and "the merely man"—to use Campbell's demarcations. But what if we stay with the initial relationship between Care/Cura and clay or, more particularly, the initial moment in which Care/Cura picks up this material, before fashioning it decisively into any kind of form, human or otherwise? We may then, I think, be able to lean paradigmatically on Heidegger's reading of this tale, without following both the narrative and its philosophical trajectory solely toward the human end. Without spirit granted from Jupiter or body granted from Earth, this nonhuman living clay material exists in suspended time, but it is still nonetheless identified by care and thus invested with infinite formal and functional possibilities to be granted again in time, again in life and death.

PERFORMING MAINTENANCE

In light of this mythical positing of care as ontologically primordial to the potentiality of matter and being in time, what could the expanded temporality of care entail? If care is integral to the determination of

something as living, how specifically is the time, and timing, of care necessary to the material development, sustenance, and renewal of living and dying matter, both human and nonhuman? What kinds of material infrastructures are required if we are caring for living forms and bodies that are not only or not fully human, and yet also for the processes and practices of living in time, through time, and across time toward death? In other words, what does it mean to care for both the material indeterminacies and the temporal contingencies of living forms? In order to propose answers to these kinds of questions, I want to focus on the materiality of the ancient Roman figure of care in combination with the ephemerality of care as a process and practice in order to specify its centrality as conditioned over time. With this in mind, I turn away from mythical invocation and toward both the material infrastructures as well as the immaterial practices that maintain life, which is also to situate the rituals of care instigated by the Tissue Culture and Art Project within a parallel performance and conceptual art history.

As Kelly Rafferty makes clear: "Catts and Zurr are not the first artists to make art about the labor that goes into maintaining humble, collaborative, dynamic living communities that are in need of care."[24] Rafferty draws necessary and otherwise unacknowledged lines of connection between TC&A's maintenance rituals and the feminist performance art of Mierle Laderman Ukeles, Mary Kelly, and Betye Saar that began in the 1960s and that sought to make visible and legible the ongoing, undervalued labor—gendered, classed, and raced—of nurturing children and families. In deftly charting out these similarities, Rafferty compels us to think more specifically about the processes of maintenance that are in fact materialized by TC&A's time-based rituals as well as those that remain dematerialized and invisible.[25] In doing so, we begin to recognize the intertwined material and immaterial practices of care.

To continue thinking along these lines, I turn to performance theorist Shannon Jackson's reading of the complex entanglement of material and immaterial labor within Mierle Laderman Ukeles's art and performance pieces, which offers a pathway to navigate the visible

and invisible, objects and subjects of maintenance. In 1969, Ukeles wrote her "Manifesto for Maintenance Art," a radical proposal for an exhibition to be titled *CARE*, that asked: "After the sourball of every revolution/after the revolution, who's going to pick up the garbage on Monday morning?"[26] Jackson contends that Ukeles, in answering such a provocation, "trained attention on the ceaseless, repetitive motions of household labor, not to argue her way out of doing it (as a certain class-conscious liberal feminist position might have done) but to expose the pervasive necessity of such labor, even in both revolutionary and artistic contexts that would rather consider themselves free and independent of such needs."[27] Later in 1973, Ukeles developed a series of self-titled "maintenance art" performances at the Wadsworth Atheneum in Hartford, Connecticut. In two of the performances, Ukeles washed the entry plaza and steps of the museum, on her hands and knees for four hours straight. She then scrubbed the floors inside the exhibition galleries for another four hours, making publicly visible the menial and domestic tasks of cleaning, washing, dusting, and tidying that are usually associated with women's work. Her actions also revealed the extent to which the museum's pristine self-presentation, and its immaculate spaces supposedly emblematic of neutral space, instead rely upon the unseen and devalued labor of daily maintenance.

By emphasizing these hidden dependencies, Ukeles positioned the site of the museum within a hierarchical system of labor relations and also within a complex division of social and gender roles. Yet Ukeles's exposure of the labored work of artistic production and reception also complicates the radical dematerialized ephemerality of concurrent conceptual art practices, as theorized by her own early supporter, Lucy Lippard—practices without a solid and fixed object orientation and that instead offer experiences of duration, endurance, process, and disappearance.[28] As Jackson argues, however: "Maintenance is a structure that exposed the disavowed durational activity behind a static object as well as the materialist activity that supported 'dematerialized' creativity, a realization that called the bluff of the art experimentation of the era."[29] She goes on to propose: "The analytics of de-materialization could sideline the hypermateriality of a maintenance consciousness,

one that was less preoccupied with watching the erosion of the world than with resupplying a world ceaselessly in need of repair."[30] Understanding Jackson's claim—that even dematerialized and ephemeral performance practices require material foundations and thus necessitate material maintenance and renewal—is key to making legible any practice of giving and receiving care to living forms.

So if we understand TC&A's rituals of care as material maintenance, along the lines of Ukeles's maintenance art and also in relation to dematerialized performance practices, then we can begin not only to foreground but to support the material conditions that activate the immaterially temporal practices of care directed toward forms and bodies that are simultaneously maintaining and being maintained by each other, both visibly and invisibly. Maintenance, I am therefore arguing, can be understood as the materially directed and temporal practice of care that develops intertwined material and immaterial infrastructures of dependency among increasingly blurred distinctions of living forms. But we must also remember that TC&A's care over time involves death and that maintenance encompasses acts of both nurturing and ending life. Countering the impulse to keep things and beings alive indeterminately, the death of tissues, bodies, and structures is integral to the activities of sustainability. In fact, programmed cell death, or apoptosis, is advantageous for the sustainability of multicellular organisms; without these signals, uncontrolled cell proliferation occurs, as is the case with cancer. Maintenance of the system, therefore, incorporates the death of its components; maintaining and ending life are not at odds but rather are both necessary in developing ongoing material and immaterial infrastructures of care.

PRESERVING AND CLASSIFYING

But when it comes to maintaining new and ever-expanding micromanifestations of life and directing care toward living entities existing inside and outside of human and nonhuman bodies, we must also acknowledge that only certain, and not all, forms of living matter accrue maintenance over time. By extension then, only some forms of

life unfold in and through care and thus may not even qualify as life, especially if we understand care as fundamentally constituting living formations. In 2007, Oron Catts and Ionat Zurr created *NoArk,* their self-described "vessel for neo/sub life" in order to respond to the growing mass of disassociated and fragmented living tissues and cells, or sublife, already existing in the thousands of tons across pharmacological and biological research centers that get disposed of and destroyed without much thought or fanfare (Figure 14). Catts and Zurr's *NoArk* attempts to reconstitute, preserve, and care for these fragments as new and primarily illegible forms of life.

Beginning in the 1980s, the emergent technoscience was recombinant DNA: the ability to cut up and join together DNA molecules in

FIGURE 14. *NoArk,* the Tissue Culture and Art Project, 2008. From the *Biotechnique* exhibition, Yerba Buena Center for the Arts, San Francisco, California. Courtesy of the Tissue Culture and Art Project (Oron Catts and Ionat Zurr).

order to study the functionality of certain sequences. This also allowed scientists to generate, in bulk, the protein that might be coded by that sequence. Recombinant DNA, therefore, granted the life sciences the ability to create a product out of cellular and molecular matter, which opened the gateway for the biotech industry. These technologies had been bolstered by the enormous funding granted to the National Institutes of Health by President Ronald Reagan as well as the willingness of venture capitalists to invest in the speculative strategies of numerous start-up biotech companies. In the legal sphere, the passing of the 1980 Bayh-Dole Act opened up the transfer of technology between academia and industry, which enabled the rapid commercialization of biotechnological research, then easily patented as biotech property.[31] Covering such ground in her study of *Life as Surplus,* Melinda Cooper argues: "As the realms of biological (re)production and capital accumulation move close together, it is becoming difficult to think about the life sciences without invoking the traditional concepts of political economy—production, value, growth, crisis, resistance, and revolution."[32] For Cooper, traditional economic categories are also being challenged by these connections. The global bioeconomy, fueled by both public and private investments into the billions, is organized around the latent value of biological processes and the surplus of "biovalue," to use the term coined by Catherine Waldby in 2000—a surplus that is leveraged and circulated as "biocapital."[33] As biological and pharmacological institutions continue to modify living organisms or recombine cell-lines and tissues, a large amount of undistinguishable, unclassifiable "sub" living forms are excised and rendered useless.

Catt and Zurr describe their own collected biomasses that grow inside *NoArk* as "semi-living" organisms, since they originate from tissue samples, and yet they have no living parentage or, indeed, kinship and, therefore, no lineage of relationality or site of belonging. Within the bioreactor, however, the "sublife neo-organisms" become reincorporated into newly organized systems, to be preserved, classified, and maintained as living. In its multiply exhibited forms—in Perth, Portugal, and Madrid in 2007, in 2008 in San Francisco, then in its revised

version as *NoArk II* in Norway, Adelaide, New York City, Melbourne, and Buffalo from 2008 to 2010, then again as *Odd Neolifism* in Brisbane, and finally as *NoArk Revisited: Odd Neolifism* at the *Translife* exhibition in Beijing in 2011—this ongoing project consisted of separate transparent containers housing collections of animal and plant tissues and specimens, as well as the support systems and technologies necessary to maintain the range of living matter (Figure 15).

In reclassifying a range of matter through the very act of maintenance and preservation, *NoArk* provides shelter and life support for the parts, units, and systems that precariously and tenuously expand how we determine which formations of life demand and receive care. It seems, however, too extensive to qualify each and every "sub" and "neo" form of living matter through the framework of care. For their part, Catts and Zurr have coined the term "neolifism" to correspond to the fetishistic relationship we have to biotechnological and laboratory-grown living forms that nonetheless remain sequestered from public visibility for the most part, since they challenge conventions of maintenance as well as preservation.[34] As they explain:

> Since we developed *NoArk,* more and more museums have started to collect fragments of life, frozen cells that represent the whole. These are a new addition to the stuffed animals and specimens in jars. Here, the technology of collection is converging with the technology of making strange. New life forms are entering collections, but the collection is not complete. . . . The "odd neolife" is not there in our natural history collections; the lab-grown, lab-modified life forms are still absent.[35]

Collection and preservation, particularly within museum conventions, determine static infrastructures of maintenance in which living processes are halted and care is given to entities, however fragmented and odd, within a suspension of time. In *NoArk,* an expanded collection of manipulated life, already occurring in labs every day, makes its case to join the halls of other preserved matter. But beyond making strange the expanded array of what we interact with as life, this work demonstrates

that the very acts of maintaining and caring for these sub/neo forms over a course of time fundamentally qualifies them as living.

INFRASTRUCTURAL PLASTICITIES

But what happens when we attempt to maintain things-in-growth or to care for the plasticity and temporality of living things? How can we care for the dependent encounters and exchanges that maintain the

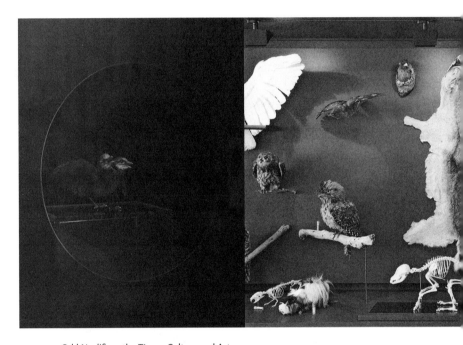

FIGURE 15. *Odd Neolifism,* the Tissue Culture and Art Project, 2010. Bioreactor, glass, CO_2, nutrient solution, living cells, and taxidermy and preserved specimens on loan from the collections of QM Loans, Queensland Museum, Brisbane; the University of Queensland's Zoology Museum, courtesy of the School of Biological Sciences; and David Burnett, Curator International Art, QAG/GoMA. Commissioned for *21st Century: Art in the First Decade.* Photograph by Natasha Harth. Courtesy of Queensland Art Gallery/Gallery of Modern Art.

range of variability and vulnerability of life? In contrast with static infrastructures of preservation and in dialogue with the ongoing temporality of material maintenance, as well as the centrality of temporality within the ontology of care, TC&A's growing, maintaining, and killing practices suggest a mode of care that is indeterminately variable, thus revising the directives of care with changing developments and establishing plastic infrastructures that may or may not fully maintain living formations in the same way or the same time.

Central to tissue-culturing technologies, plasticity is described by Hannah Landecker as "the ability of living things to go on living, synthesizing proteins, moving, reproducing, and so on, despite catastrophic interference in their constitution, environment or form. The ability to grow cells outside of bodies in artificial environments or on scaffolds, to puncture eggs and inject foreign things in them, to cut and paste genetic material and so on without killing the organism in question altogether, are also good examples of plasticity."[36] For Landecker, the history of biotechnology since the 1900s involves the increasing ability to manipulate plastic living matter, shifting our definition of what it means to be not only human but also biological. Reshaping, pushing, and pulling living forms expand the time frame through which these forms endure, oftentimes toward the infinite, as the many existing immortal cell lines would indicate. Indeed, extended temporality and expanded plasticity go hand in hand, since, as Landecker puts it, "reshaping form is also a reshaping of how life exists in time."[37] Caring for the ongoing forming and reforming of life, which for TC&A includes the punctuation of death, can then also remain plastic. Through the multiple growths of each tissue form, and through these tissues' variable unfolding lives as well as their range of deaths, and therefore through re-exhibitions and reperformances, TC&A introduces plastic infrastructures for living, semiliving, and nonliving matter to exist and re-exist across time, however discontinuously. I would argue that these repeated and revisable practices encourage us to formulate a mode of care that considers unpredictable variations in life, accidents and failures in growth, development and maintenance as well as multiple deaths, as altogether sustaining the potentiality and caring for the contingency of life itself. Reformation here is not endless repetition or reiteration without revision or change but rather an inexact series of variable beginnings, developments, and ends that cannot be planned in advance.

TC&A re-exhibits its work around the world as any artist would, but for TC&A this means generating the tissue sculptures again and again at each new site. In practical terms, the transfer of living matter across borders is legally problematic in most cases and always ex-

tremely expensive and, in any event, cultured tissues are often too delicate to travel. Conceptually, the necessity of regrowth provides unforeseen plastic variations in both form and temporality; polymer scaffolds are newly seeded with cells, and yet neither the structural outcome nor the unfolding time of the living tissues can be predicted. TC&A's first publicly exhibited living tissue-cultured work, the *Semi-living Worry Dolls,* has been regrown, re-exhibited, maintained, and killed multiple times since their initial entry into life in 2000. Catts and Zurr have explored different practices of seeding cells over and into the scaffolds, depending on the different cells and scaffolds used each time. As they specify in 2002:

> To date we have grown epithelial (skin) tissue from rabbits, rats and mice, connective tissue from mice, rats and pigs, muscle tissue from rats, sheep and goldfish, bone and cartilage tissues from pigs, rats and sheep, mesenchymal cells (bone-marrow stem cells) from pigs, and neurons from goldfish. The biocompatible substrates that we have used to produce 3D scaffolds/constructs are: glass, hydro-gels (P(HEMA) collagen), biodegradable/bio-absorbable polymers (poly-glycolic acid [PGA], PLGA, P4HB) and surgical sutures.[38]

In addition, Catts and Zurr also started to experiment with "dynamic seeding," in contrast with the conventions of statically seeding the cells by dripping cell media solution in stationary conditions.[39] Working with the artist Adam Zaretsky on their *Pig Wings* project, they created the "Dynamic Seeding Musical Bioreactor" in order to explore the capacity of vibrations produced by music and audible sound waves, to coax the tissues to grow and develop in variable and unpredictable ways.[40] Right before Napster was declared illegal and shut down, the artists downloaded all the mp3s with the keyword "pig"—from "War Pig" by Black Sabbath to "Blue Christmas" by Porky Pig. For the next three weeks, they played these pig-related songs via special vibrating speakers to the bone marrow stem cells that were seeded onto porous polymer scaffolds. The idea was that the vibrations would more widely diffuse and vary the physical embedding of the cells into the construct, and in fact those wings that were subjected to music

differed considerably in tissue morphology and distribution than those that were deprived of music. During the 2011 *Visceral* exhibition as well, the sound from the whispered worries were amplified and delivered to the dolls-in-growth, and although the artists did not analyze the effects of these vibrations, it seems very likely that these sound waves affected the development, form, and morphology of the tissue figures.[41] Giving up control and encouraging unexpected variability become foundational factors in both growing and maintaining life, while the capacity to reform living, semiliving, and dying things in different shapes and in different times allows for elastic infrastructures and performances of care.

In witnessing what TC&A is doing and redoing, we come to recognize, however uncomfortably, that we cannot precisely determine in what form and in what time living forms come into being, and likewise we also cannot always control when they die. In 2008, in perhaps its most infamous living art predicament to date, TC&A's *Victimless Leather*—a tiny jacket-shaped scaffold seeded with mouse embryonic stem cells—grew too fast and out of control; an arm fell off and cells sheared off the jacket, which started to clog up the nutrient flow of the entire maintenance system of its technoscientific body. The curator of the exhibition at the Museum of Modern Art in New York, Paola Antonelli, had to stop the jacket from growing and thus end its life short of the exhibition's closing date, which garnered the *New York Times* headline "Museum Kills Live Exhibit."[42] In TC&A's work, there are always numerous instantiations of life going and growing out of control, and not at all as planned, and so it becomes important to consider not just the artwork but rather the various instantiations of that work, including its inevitable failures and accidents. As a part of the exhibition *Medicine and Art: Imagining a Future for Life and Love* at the Mori Art Museum in Tokyo, the tissue jacket became infected by fungi (Figure 16). Although Catts applied an antifungal treatment, the infection nonetheless produced a flower-shaped growth positioned near one of the tiny sleeves. In addition, because the jacket had to stay alive throughout the three months of the show, which ran from November 28, 2009, to February 28, 2010 (Figure 17), the scientist Hideo

FIGURE 16. *Victimless Leather: A Prototype of Stitch-less Jacket Grown in a Technoscientific "Body,"* the Tissue Culture and Art Project, 2010. Biodegradable polymer connective and bone cells. From the *Art and Medicine* exhibition, Mori Art Museum. Courtesy of the Tissue Culture and Art Project (Oron Catts and Ionat Zurr).

Iwasaki stepped in to feed the cells and had to replace and regrow the jacket twice.[43] In yet another instance, for an Australian television documentary focusing on the collaborative art-science work occurring at SymbioticA, Catts and Zurr once again grew their *Victimless Leather.* This time, while moving the entire support system, the small jacket fell off its tiny hanger into the pool of nutrient media below. Another jacket was subsequently grown above the original one, resulting in a dual formation of one very young tissue jacket that was to be killed at the end of the documentary and one that accidentally was disintegrating.[44] Indeterminacy guides and misguides every one of these instances of life and, taken together, they all speak to the unforeseen plasticity and unpredictable temporality of living matter. In order to care not only for these multiple processes of living but also

FIGURE 17. *Victimless Leather: A Prototype of Stitch-less Jacket Grown in a Technoscientific "Body,"* the Tissue Culture and Art Project, 2010. Biodegradable polymer connective and bone cells. From the *Art and Medicine* exhibition, Mori Art Museum. Courtesy of the Tissue Culture and Art Project (Oron Catts and Ionat Zurr).

for the formal temporal contingencies that variably propel these lives and deaths, we must extend and expand our own capacity for the unexpected, to care by releasing control and letting go of intended outcomes, and to open up our static mode of maintenance, classification, and preservation by allowing for encounters and exchanges that encourage and metabolize the unexpected over time.

In a more recent series of work, *Crude Matter* (2012), TC&A explores the substrate that surrounds, transfigures, and ultimately supports the variability and viability of living forms. As Catts and Zurr explain:

> Loosely based on the story of the Golem (which literally means crude, unshaped or raw), we will explore the "alchemy-like" transformation of different materials into substrates which have the ability to support and act on life. *Crude Matter* attempts to destabilise the prevailing logic of the transformation of life into raw material for engineering ends; to bring to question the logic that seems to privilege the information embedded into DNA over the context in which life operates.[45]

In its exhibition premiere at the Laznia Centre for Contemporary Art in Gdańsk, Poland, *Crude Matter* consisted of a set of objects arranged linearly: local mud in a glass container, a white clay cube and cylinder sitting on a patch of artificial grass, petri dishes of cells, and a microscope that transmitted a vascularization process onto a computer screen (Figure 18).[46] In forthcoming exhibitions, Catts and Zurr plan on growing living forms over a variety of materials, which will all be on view, using the fibroblasts responsible for synthesizing the extracellular matrix, itself a cell's structural support system, as the substrate feeder cells on which other cells can grow. In effect then, living cells are catalyzing and maintaining the transformation of other living cells. At the 2016 Kenpoku Art Festival in Japan, Catts and Zurr, in collaboration with Mike Bianco, debuted two new works: *The Hivecubator* and *The Compostcubator* (Figures 19 and 20). Live bees and bacteria were used, respectively, to generate enough heat and carbon dioxide to culture living cells—bee, mice, and potentially even human.[47] This

new series of work, *Vessels of Care and Control,* continues to expose the ever-developing dependencies between a range of different living beings, as well as the materials, structures, and environments that together perform the care through which multiple living forms are capable of being maintained over time.

As primordial to the formation of beings and things, care conditions life and in turn is conditioned by time. Through time, this conditioning is precarious, plastic, and unpredictable; it must be both materially and immaterially maintained, can be discontinuous and unequal, but remains capacious in its variety. To give and receive care, we must first give in to and then give ourselves up to these conditions, which means to give in to and to give ourselves up to the indeterminate temporality of living, semiliving, and dying human and nonhuman, organic and inorganic, things and beings—a series of surrenders that is far from easy for most of us, if only partially possible.

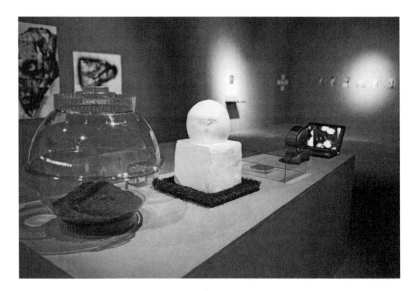

FIGURE 18. *Crude Life,* the Tissue Culture and Art Project, 2012. Laznia Centre for Contemporary Art, Gdańsk, Poland. Courtesy of the Tissue Culture and Art Project (Oron Catts and Ionat Zurr).

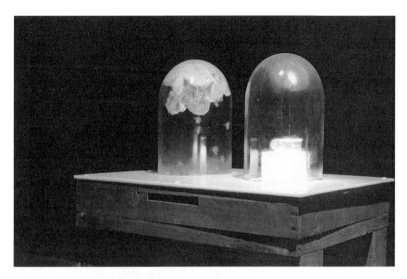

FIGURE 19. *The Hivecubator*, the Tissue Culture and Art Project, 2016. Kenpoku Art Festival, Japan. Photograph by Keizo Kioku. Courtesy of the Tissue Culture and Art Project (Oron Catts and Ionat Zurr).

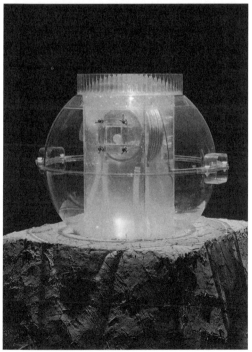

FIGURE 20. *The Compostcubator*, the Tissue Culture and Art Project, 2016. Kenpoku Art Festival, Japan. Photograph by Keizo Kioku. Courtesy of the Tissue Culture and Art Project (Oron Catts and Ionat Zurr).

To determine any infrastructure of care under these terms, we must consider how encounters and exchanges between, across, and within various cells, tissues, scaffolds, and situations allow for some thing to momentarily and vulnerably sustain another thing, however incompletely. By encouraging the reinstantiation of these temporary moments, materials, and structures of maintenance, without predicting and programming others to come, we begin to slowly approach an ever-expandable practice of care.

VITAL CONTEXTS

Morphology, Mutability, and
Sabin+Jones LabStudio

Curtains and caverns composed of seventy-five thousand intricately connected plastic zip ties engulf any viewer entering the large-scale immersive environment. Measuring twelve feet high, fifteen feet wide, and eight feet in depth, *Branching Morphogenesis* was designed by Jenny Sabin and Andrew Lucia in collaboration with Peter Lloyd Jones and colleagues at LabStudio and initially presented at the 2008 SIGGRAPH exhibition in Los Angeles and the following year at Ars Electronica in Linz, Austria (Figure 21). Cofounded in 2006 by Sabin and Jones at the University of Pennsylvania, LabStudio is a collaborative research group that works across architecture and cell biology, with its members now based at Cornell, Stanford, and Jefferson Universities. In addition to its exhibited form, an image of the installation appeared on the February 19, 2010, cover of *Science* magazine, and the project won the 2010 International Science and Engineering Visualization Challenge award, cosponsored by the American Association for the Advancement of Science and the National Science Foundation.

Branching Morphogenesis emerged from real-time imaging and time-lapse filming of cell interactions occurring in the lining of blood vessels in the lungs. LabStudio cultured these lung endothelial cells in different microenvironments and traced the cells' capacity to move, cohere, and network over time. Culminating in five interwoven and undulated walls, the installation drastically scaled up and combined five slices of time during which the cells exerted differing forces on their various

environments through their interconnection, motion, and distribution (Figure 22). With projects such as *Branching Morphogenesis,* LabStudio has examined infrastructural alliances across spatial frameworks within and outside of both cellular and architectural morphologies, while also exposing surrounding contexts as always variable, changing along with the emerging micro to macro forms.

Tracking and visualizing the exchanges between cells, on the one hand, and the structure and force of their environment, on the other, has driven Sabin and Jones to explore what they call "reciprocity in context, albeit normal or pathological."[1] On a microscale, cells move toward and away from each other in concert with a flexibly adaptable and supportive environment that, in turn, either affords or prohibits necessary cellular activities. These unfolding reciprocities enact the mutually constitutive yet heterogeneous dependencies from which cells are formed as either healthy or diseased; such interactions also affirm the degree to which cellular microenvironments are capable of structurally remodeling themselves to continue supporting healthy

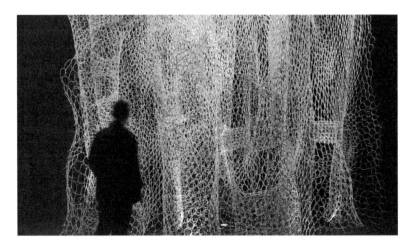

FIGURE 21. *Branching Morphogenesis,* Jenny E. Sabin, Andrew Lucia, and Peter Lloyd Jones, Sabin+Jones LabStudio, University of Pennsylvania, 2008. Courtesy of Jenny E. Sabin and Peter Lloyd Jones.

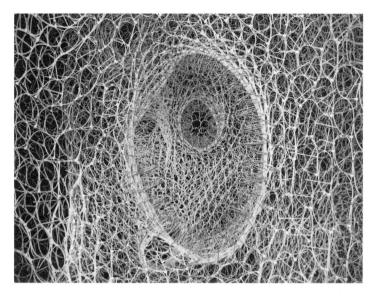

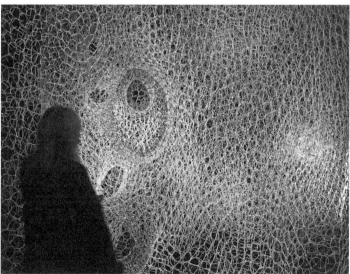

FIGURE 22. *Branching Morphogenesis*, Jenny E. Sabin,
Andrew Lucia, and Peter Lloyd Jones, Sabin+Jones
LabStudio, University of Pennsylvania, 2008. Courtesy
of Jenny E. Sabin and Peter Lloyd Jones.

cell development and behavior over time. While the last chapter introduced material infrastructures and immaterial processes of care as integral to the maintenance of cell and tissue formation, this chapter turns to the structure and force of the encompassing spatial environment that varies in accordance with such carefully tended forms over time. As such, a turn toward the architectural seems warranted, with LabStudio's microcellular experiments and their scaled-up structural models demonstrating that processes of formation are inextricably tied not only to the material specificities but also significantly to the ongoing mutability of situational conditions that are themselves constantly in flux. Following ongoing and multiple feedback loops between form and context both within and outside of the biological, LabStudio materializes the structural effects of reciprocity in which form and context are revised repeatedly through acts of dynamic mutual exchange across different temporal registers.

MICROENVIRONMENTS AND THE EXTRACELLULAR MATRIX

Since Jenny Sabin's architectural background in textile development, weaving, and computation coalesced with Peter Lloyd Jones's research on the dynamic feedback loops between a cell and its local environment, LabStudio has been concerned with how forms emerge and then vary within particular situations over time. Working in multiple scales and across multiple durations, Sabin and Jones's exploration of structural development and infrastructural behavior calls attention to the ways in which fluctuations within external surroundings influence internal formal evolutions, transformations, and deformations. To that end, LabStudio has been interested in the form and function of the extracellular matrix (ECM) or the microenvironment of the cell, most particularly in its interaction with intracellular components and processes occurring during tissue development.

Found in all tissues and organs, the extracellular matrix is the structural scaffolding to which living cells anchor and through which cells distribute, migrate, and network; its specific heterogeneous constitution affects these activities, as well as oversees the regulation of

cell and tissue morphogenesis, differentiation, and homeostasis.[2] The ECM is thus integral for cell and tissue development, transformation, and maintenance over time. Far from being a stable and fixed structure, as researchers at UCSF explain, "the tissue ECM is a highly dynamic entity that continuously undergoes regulated remodeling, whose precise orchestration is crucial to the maintenance of normal function."[3] With an adaptable architecture of its own, and composed of two kinds of macromolecules (proteoglycans and fibrous proteins like collagens, elastins, fibronectins, and laminins), a healthy ECM is compliant and relaxed, able to withstand tensile stresses and to restructure itself. A diseased ECM, however, denotes modified cell organization often occurring as a result of aging tissues that get stiffer, less elastic, and weaker, therefore also compromising the flexibility of the surroundings. In the case of cancer, for example, tumor development and stiffening has been linked to ECM rigidity, as tumor cells and their microenvironment engage in a feedback loop that propitiates tumor growth over time.[4]

Because cell biologists now recognize that the specific properties and processes of the ECM are necessary to determine either the health or pathology of cell and tissue development, researchers are isolating ECMs as well as developing synthetic ones in order to study the dynamic interplay between intra- and extracellular structure and behavior. With its scaffold organization as well as its ability to dynamically reorganize, the variable architecture of the ECM is capable of being used to facilitate new cell and tissue growth, which means that an ECM can be harvested from one type of tissue and reseeded with cells from another. So, for example, an ECM from the bladder of a pig can be stripped of all its cells, or decellularized, and used as an empty three-dimensional structure onto which new cells, such as human muscle cells, can attach, network, and develop into new tissue.[5] To support this very process, in 2010 the U.S. Department of Defense's Office of Technology Transitions granted a multimillion-dollar contract to the University of Pittsburgh Medical Center and the McGowan Institute for Regenerative Medicine so they could begin human trials of ECM-driven tissue regeneration in soldiers with muscle injuries,

decellularizing ECMs from pig bladders and reseeding them with human muscle cells. And, in fact, applications of reseeded ECM structures are continuously expanding as a 2013 clinical report states:

> ECM-based tissue engineering strategies are already successfully being used clinically for the regeneration of a range of different tissues, including heart valves, trachea, muscle, tendon, and abdominal walls, with matrices derived from bladder and small intestinal submucosa the most widely used implants.[6]

In grounding so much of this recent hype, however, we must consider that a decellularized ECM can only be a transferable structural biomaterial if it is able to support specific tissue formation; the viability of this process is tied to each ECM's innate properties as well as its capacity to interact seamlessly with the cellular components into which it is introduced.[7] This means that the decellularized extracellular matrix would potentially be capable of propitiating new cells and tissue only if in sync with the materiality of its new location, catalyzing mutable feedback loops between its own structural specificities and the new cells seeded onto it. These variable processes, adaptable interactions, and flexible relations instigated by the ECM can then influence the functional information housed within cells, affording a variety of cellular behaviors and tissue morphologies.

LabStudio has experimented with different ECM constitutions—healthy and diseased, flexible and stiff, variable and unchanging—and their effects on both tissue generation and degeneration over time. In *Branching Morphogenesis,* the LabStudio team was examining the parameters that either enable or prohibit the generation and maintenance of blood vessel networks that line the lungs. A year later at SIGGRAPH 2009 in New Orleans, Jenny Sabin and Andrew Lucia exhibited another project they had been developing in conjunction with Peter Lloyd Jones, as well as production and research teams at LabStudio, focusing their attention this time to the development and connectivity of human mammary epithelial cells. Their collaborative work, *Ground Substance,* visualizes the networked contouring of cell and tissue formation in both healthy and tumor-like microenvironments of the

mammary gland (Figure 23). Pictured on the February 2010 cover of the *American Journal of Pathology, Ground Substance* also presented research that LabStudio had garnered over time regarding the strong influence of the total tissue microenvironment on tumor formation in breast cancer.[8] In biological terms, ground substance is composed of the nonfibrous components of the extracellular matrix, such as water, glycosaminoglycans, proteoglycans, and glycoproteins. An amorphous gel that is usually invisible on slide preparations because it is typically removed, this portion of the ECM microenvironment becomes visible in *Ground Substance* because LabStudio spatially interprets its transformative effects on cell formation over time.[9] Utilizing 3D printing and rapid prototyping technologies, the LabStudio team first produced small ceramic models representing the impact of ground substance on human mammary epithelial cell and tissue formation (Figure 24a). Based on these objects, they created the 146 individual modules that would make up the final work, stringing together each component with aluminum rods and cable ties (Figure 24b). Suspending particular

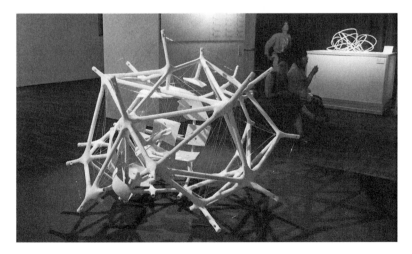

FIGURE 23. *Ground Substance,* Jenny E. Sabin,
Andrew Lucia, and Peter Lloyd Jones, Sabin+Jones
LabStudio, University of Pennsylvania, 2009.
Courtesy of Jenny E. Sabin and Peter Lloyd Jones.

a

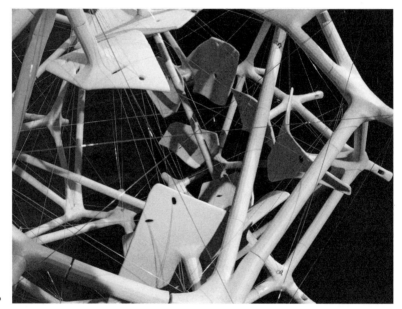

b

FIGURE 24. *Ground Substance,* Jenny E. Sabin,
Andrew Lucia, and Peter Lloyd Jones, Sabin+Jones
LabStudio, University of Pennsylvania, 2009.
Courtesy of Jenny E. Sabin and Peter Lloyd Jones.

slices of time, *Ground Substance* simultaneously manifests multiple processes of cellular morphogenesis and mobility as influenced by seemingly innocuous surrounding matter.

MACROENVIRONMENTS AND DIGITAL MORPHOGENESIS

In tandem with LabStudio's ongoing research into the extracellular matrix translated into and substantiated as large-scale installation objects, Jenny Sabin has also explored parallel feedback loops occurring on a macroscale. Sabin was a founding member of the Nonlinear Systems Organization, a research group initiated by the structural engineer Cecil Balmond at PennDesign that examines the intersections between architecture, material science, and the complex algorithmic mathematics behind generative architecture's digital morphogenesis. The group caught the attention of Peter Lloyd Jones; nonlinear feedback loops, in Jones's disciplinary background, account for the heterogeneous, multidirectional, dynamic relationships between mobile and networking cells, and between cells and their ECM.[10] So the story goes that Jones auspiciously walked into one of their meetings thinking he was doing a similar kind of work, and thus their LabStudio collaboration was born—an exchange of both skills and concerns that frame multiscalar analyses of generative, mutable, and mobile formations in flexible and adaptable contexts.[11] While the two state that their goal is to "understand the dynamic and reciprocal relationships that exist between cells (i.e., a component), their extracellular matrix (i.e., an environment), and code (i.e., genetic information)," they also add that "this exchange of information between the outside of the cell and its interior environment and back again presents a potent ecological model for architecture based upon an understanding of how context or environment shares a reciprocal relationship with code, geometry, and matter."[12] Alongside explorations on a microenvironmental scale, on a macro register their work attests to integral correlations that unfold between internal and external structural forces, rendering in larger spatial terms a cellular framework for gauging how form may generate sustained effects on its surroundings and how those surroundings may

activate as well as reroute those effects. Indeed, across both LabStudio's biological research experiments and architectural installation projects, the mutable composition and activity of microcellular environments offer an ecosystemic approach to macrostructural generation, maintenance, and transformation (the effects of which the next chapter will take up more explicitly).

This kind of cross-spatial conversation between cells and architectural structures evokes Buckminster Fuller's early twentieth-century Energetic-Synergetic geometry. Fuller contended that natural forms develop as forces of tension and compression reciprocally act upon matter, where tension instead of compression is the stronger and more versatile counterpart.[13] Coined midcentury by Fuller and demonstrated in the sculptures of his student Kenneth Snelson, as well as in Fuller's own geodesic domes, *tensegrity* is defined as the flexible integrity of architectural form made possible through dynamic and variable impacts of tension. Structural equilibrium and resilience is attributed to a unified structure's ability to respond, adjust, and reorient to internal and external stresses, while each infrastructural component remains interconnected and balanced by both tensile and compressive vectors. Fuller's understanding of tensegrity on a macroscale can also be translated from architecture to cell biology, if we note how tension is continuously transmitted within, throughout, and across the structure of a cell. Microfilaments, intermediate filaments, and microtubules linking the nucleus to the cell's external microenvironment are able to catalyze changes within the cell when forces are applied to the cell surface. According to Donald Ingber, who first proposed this concept of cellular tensegrity, the filaments and tubules of a cell's cytoskeleton account for mutable cellular structure and mobile cellular behavior. But cells also need to anchor themselves to an external substrate, their ECM, and as they do so they exert tensile forces on this malleable matrix environment that in turn determines each cell's shape over time.[14] These structural interconnections reaching from genes and chromosomes in a cell's nucleus all the way to the surrounding substrate ECM environment define cellular formation, organization, and function relationally and reciprocally, as the material and information within a

cell respond to, as well as anticipate, forceful variables in its external surroundings, and vice versa.

Following Buckminster Fuller and aligned with Ingber's understanding of the correlative microstructural integrity of cellular forms, certain contemporary architects and theorists have been conceptualizing contemporary architecture as a living responsive system of force fields, dynamic components, and contexts occurring on a macroscale. Neil Leach, for example, proposes that present-day architecture's own privileging of morphogenesis emphasizes "form-finding over form-making, on bottom-up over top-down processes, and on formation rather than form."[15] Like its biological counterpart, digital architectural morphogenesis is generative, attuned to the development and transformation of structural forms with emergent and adaptive properties over time. Concerned with continuous curves and relative experiences of space in time, and thus with non-Euclidean geometry, contemporary architecture's digitally generated topologies turn our attention toward the effects and representations of temporal dynamics and mobile force fields. This means, according to Branko Kolarevic, that "emphasis shifts away from particular forms of expression to relations that exist between and within an existing site and the proposed program. These interdependencies then become the structuring, organizing principle for the generation and transformation of form."[16] Within such a program, then, parameters for a range of structures are declared, which in turn catalyzes the generation of multiple surfaces and shapes that are then contoured and volumized through any number of variable forces both within and outside of the burgeoning form. For Kolarevic, this process of digital morphogenesis embraces the "precise indeterminacy" of parametrics, whereby:

> a system of influences, relations, constrains or rules is defined first through the processes of *in-formation*, and its temporal behavior is specified; the resulting structure of interdependencies is often given some generic form *(formation)*, which is then subjected to the processes of *de-formation* or *trans-formation*, driven by those very same relations, influences or rules imbedded within the system itself.[17]

Finding form in this way produces a number of unexpected results across a range of parameters that are not only spatial and structural but also temporal. To return to LabStudio's architectural projects then, ongoing exchanges between internal and external components offer fluctuating conditions for both structural transformation and deformation, enacting a behavioral call and response between the changing form and changing site that is tracked over time and driven by unfolding material encounters.

MORPHOLOGIES IN MOTION

The dynamism of such material encounters cannot, however, only be attributed to variable forms and their surrounding sites. As we have seen, Sabin and Jones have examined on a microscale and demonstrated on a macroscale that the coherence of both tissue formation and architectural formation depends on a series of interactions and anticipations within the flexible parameters of the surrounding matrix. Within these systemic reciprocities, LabStudio's research on a cellular level also calls attention to an additional and significant factor of mobility that influences the changing relationship between morphological transformation and environmental context. The mobility of cellular components is afforded by the mutability of the surrounding situation, and this mutability, in turn, contributes to the morphological transformations of those cellular components. In conjunction with the emergent formations and reciprocal connections that are affected by the fluctuations and remodeling of a cell's microenvironment, LabStudio's research also shows that the force, direction, and rhythm of cellular motion become significantly affected by the surrounding conditions of the extracellular matrix.

In order to evaluate and then visualize the variables of cell motility in the mutable context of the ECM, from healthy to diseased, LabStudio researchers again reached outside the microscale of biology, this time from architecture to choreography. Studying with Jenny Sabin at the University of Pennsylvania, a graduate student, Jackie Wong, analyzed the movements of ice dancers, mapping the relationships between

the arms, legs, and heads of each dancer to generate visual patterns that describe the structure and direction of various movements.[18] Using Wong's choreographic visualization as a foundational starting point, Erica Savig (one of the first architecture students to work with LabStudio and, since then, a graduate student in cancer biology at Stanford) and Mathieu Tamby (a postdoctoral student in cell biology at UPenn) together devised an algorithm to analyze and understand how the tissue microenvironment, or ECM, within pulmonary arteries alters the movement of vascular smooth muscle cells.

"Jackie Wong had existing dance steps and visualized them into 3-D representations," Savig explains. "We worked backwards, visualizing cell movements to search for unseen patterns and the fine details of their unknown choreographies."[19] While working at LabStudio, Savig and Tamby began to question not only how context was determined but also how specific cellular motions could identify the particular materiality and functionality of various contexts. They wondered: "Was it possible to distinguish between different environmental conditions by looking at cell movement alone?"[20] They first seeded the smooth muscle cells in a healthy extracellular matrix of flexible fibrillar collagen, and then they seeded the cells in a denatured, nonfibrillar collagen similar to the deteriorated ECM in pulmonary arterial hypertension cases. Each set of cells moved at different velocities, coalescing in different patterns or bending into different shapes; those seeded in the nonfibrillar collagen seemed to move the most erratically. Wong's dance model helped Savig and Tamby figure out how to track these irregularly moving shapes and investigate their changing force and tempo as both catalyzed by and catalyzing the remodeling of the surrounding ECM environment. In conceptualizing cell motility and a cell's unfolding geometric shapes and alignments in terms of choreography, LabStudio researchers link morphological transformations and structural variabilities to the adaptable materiality and structuring of environmental surroundings as well as to the force and condition of movement afforded by those surroundings.

Identifying and tracking forms in motion, the early twentieth-century choreographer and theorist Rudolf von Laban, responsible for

developing a notational system for recording and analyzing dance, for-tuitously connected motion and architecture, defining movement as "living architecture—living in the sense of changing emplacements as well as changing cohesions."[21] Aligned with structural emergence, choreography occurs as structural forms and their infrastructural ex-tensions in space are situated and resituated together and apart from each other so that a correlation emerges, transforms, and disintegrates across time—a momentary configuration that lives and then dies, ap-pears and disappears. "This architecture," Laban suggests, "is created by human movements and is made up of pathways tracing shapes in space, and these we may call 'trace-forms.'"[22] For Laban, these trace-forms articulate contextual space, while the ensuing dynamic shaping of movement constitutes an integrated yet fluid spatial construction in that space. If we follow Laban, then, forms emerge in movement, and in their emergence, the surrounding space unfolds.

While Laban's emphasis remains distinctly on bodily movement and human geometries shifting in space, the contemporary choreog-rapher William Forsythe contends that the action and intention of choreography can be separated from the embodied form and practice of dance. "In the case that choreography and dance coincide, chore-ography often serves as a channel for the desire to dance. One could easily assume that the substance of choreographic thought resided ex-clusively in the body. But is it possible," asks Forsythe, "for choreog-raphy to generate expressions of its principles, a choreographic object, without the body?"[23] He goes on to explain: "A choreographic object is not a substitute for the body, but rather an alternative site for the understanding of potential instigation and organization of action to reside."[24] For Forsythe, the choreographic act models a transition from one formal state to another, and the choreographic object is the propo-sition suggesting the conditions for that transition to occur, yet not necessarily to endure, in time.

Choreographic propositions, like architectural parameters, are gen-erative of both form and spatial situation as well as the entangled mate-rial, spatial, and temporal contingencies that insistently influence the

variable formation of objects and their changeable environments. As the artist-philosopher Erin Manning posits:

> Forsythe's choreographic process creates conditions for events. When an object becomes the attractor for the event, it in-gathers the event toward the object's dynamic capacity for reconfiguring spacetimes of composition. . . . These "objects" are in fact propositions co-constituted by the environments they make possible. . . . We could call these objects "choreographic objectiles" to bring to them the sense of incipient movement their dynamic participation within the relational environment calls forth.[25]

As propositions that catalyze and then are entangled materially within surrounding spatial systems, choreographic objectiles elicit the action of environment constitution, which propels the events of interaction or exchange between objects and between object and environment. These encounters, in turn, induce object transformations, and then the cycle continues as the system itself mutates in time.

Following this trajectory, and in line with LabStudio's research on motility, we could consider a vascular muscle cell as a choreographic object—an objectile navigating its way through healthy or diseased microenvironments, attaching and detaching from flexible or rigid matrices, toward and away from other cells (Figure 25). This would give us a framework to think about the latent motility of cells as providing the conditions for variable morphological transitions over time as well situational dependencies and systemic reciprocities between object, event, and environment. Such choreographic thinking would also foreground the materiality of context, as we come to understand that what surrounds a body, a building, or a cell is not empty, invisible, or acquiescent, but rather substantial, variable, and impactful. As we have seen throughout LabStudio's practice, the mutable materiality of the extracellular matrix that surrounds and anchors cells serves as a structural as well as a contextual platform for morphogenesis; in turn, multiscalar forms are generated, shaped, and impelled to move and mutate, transform, and deform, as much in relation to outside forces as those from within.

time (sequence)

time (frequency duration)

Denatured

time (sequence)

time (frequency duration)

Native

FIGURE 25. Image differencing of denatured smooth muscle cells and sonic meshes of denatured and native motile cells. Andrew Lucia, Sabin+Jones LabStudio, University of Pennsylvania. Courtesy of Jenny E. Sabin and Peter Lloyd Jones.

MUTABLE RECIPROCITIES

By instigating biological research within a lab and materially transferring those explorations from micro- to macroscales, LabStudio proposes parallel and ongoing pathways between cell biology and architecture with respect to the development and transformation of three-dimensional forms within multiple, changeable environments. Yet the reciprocities between cell biology and architecture remain generative rather than prescriptive, in dialogue rather than in sync. Research undertaken within dynamic cellular microenvironments is capable of being translated and then visualized on an architectural register, as structural installations materialize and momentarily pause macroenvironmental force fields, tensions, and exchanges ongoing between components and contexts. As Sabin and Jones suggest:

> Perhaps architecture can take a cue from biology in matching the complexity of its generative design models to the very dynamic features of the living environment and organic milieu in which the architecture is a part. Or, perhaps architects might learn from these biological models so that architecture acquires "tissueness" or "cellness," and is not merely "cell- or tissue-like."[26]

Indeed, for any form to take on, rather than to be like, the morphology of cells and tissues, a delicate and inexact balancing act has to be found between inbound and outbound geometries and forces as well as between internal and external configurations, priorities, and pressures. Each of these properties and directions, from within and from without, are linked together vulnerably and contingently, each affecting others reciprocally but not equally or similarly over time.

LabStudio spatially materializes this call and response of formal shaping, conditioning, mutating, and moving from membrane to matrix and then outward to the macroenvironment, both making legible and allowing us to experience the situational frameworks within which morphologies, distributed networks, and mobile encounters unfold in time. Activating scalar parallels and patterns in form-finding processes across microbiology and architecture, their work recognizes that forming something always both instigates and is instigated by

external dependencies. According to and beyond the cellular, we learn that forceful impacts and momentary alliances between the inter-connected structural components within and outside of any formal boundary are both generative and yet also unsettling to that form's stability. Standing within LabStudio's structural explorations, we are challenged to remain within the very tenuousness of shaping and en-closing and, thus, to face the enduring possibility of both transforma-tion and deformation, of the ongoing influence of what may be con-tingently marked off as outside. In doing so, we are able to recognize that context is not only the condition and the circumstance of forma-tion but also, as elicited by the word's etymological history, a temporal practice of joining-together and interweaving of matter, of structure, of situation, of event and environment.

VITAL ECOLOGIES

Protocells and Hylozoic Ground

Droplets of sodium hydroxide in olive oil, when in motion, produce crystalline skins that are stretched through the oil, giving rise to highly complex microforms. These forms can be structurally directed by changing the chemical properties of their surrounding medium, which in turn instigates internal metabolic functions within the droplets. Acting as precursors for living cells without the regulatory system of DNA, these cell-like entities can then be manipulated to alter the micromatter around them, chemically remodeling and repairing their environment (Figure 26). Because these lifelike but not-quite-living protocells enact their own dynamic self-assembly and metabolic transformations, for Rachel Armstrong they are also capable of producing and modifying a range of infrastructures from extracellular matrices to ecosystems.

An intricate netting of sensor lashes, breathing pores, swallowing actuators, whiskers, glands, filter layers, clamping needles, and probes fall from a scaffold truss above. Bladder clusters of incubators, flasks, membranes, and islands housing protocells and chells are nestled throughout. Together these combined mechanized and biological systems initiate a breathing cycle in which air and particulate matter flow up and down through the meshed canopies in a feedback loop. Movements of bodies throughout the component environment are tracked and read by multiple kinetic sensors, feeding temperate information back into the system (Figure 27). This ongoing and

ever-changeable assemblage, developed by Philip Beesley, presents an eclectic infrastructure of interwoven organic and inorganic matter within which distinct boundaries between living and nonliving forms become almost indistinguishable and through which unexpected material collaborations continuously transform the system itself.

Both of these projects present integrated ecologies within which a range of matter and environments, including and beyond the human and the living, are inextricably bound together. While the last chapter drew attention to the force and impact of situational contexts in relation to living forms changing over time, this chapter frames such relations within larger symbiotic systems of living and nonliving matter. Whether attending to unpredictable evolutions or calculating pre-

FIGURE 26. Protocell models show how the synthetic droplet acts as a surface for the precipitation of insoluble salt. Rachel Armstrong at IDEA Laboratory, Venice, with Artwise Curators, 2015. Courtesy of Rachel Armstrong.

FIGURE 27. *Hylozoic Ground*, detail. Copyright
Philip Beesley (2010).

dictable programs, Armstrong and Beesley each develop self-propelled
ecologies in which pathways of continuity, repair, and metamorphosis
are offered, initially activated through human directives but continu-
ously forwarded by ongoing material exchanges. Taken together, these
projects map dual and unresolved impulses in the system-wide man-
agement of life-forms within structural environments: to correct, im-
prove, and rehabilitate matter with predictable, human-led outcomes,
on the one hand, and, on the other hand, to frame conditions that
allow for fluctuations through which transformations, mutations, and
evolutions within and outside of the living, much less the human,
arise. From Armstrong's to Beesley's practices, I track material ca-
pacities and physical arrangements across and beyond the living—
capacities and arrangements that are systemically integral to the conti-
nuity of life. In fact, these projects encourage us to recognize that the
vitalist condition of life across time is itself maintained by an equally

endless revision of the living and a decentralization of its recognizable forms toward a symbiosis of matter with matter—an ongoing process that ultimately foregrounds the mutability between the living and the nonliving.

PROGRAMMABLE SYSTEMS

Invested in what she calls "living architecture," Rachel Armstrong works with protocells existing at the interface between oil and water in order to explore the capacity for those molecules at the cusp of life to act as an ecosystemic self-repairing tool over time (Figure 28).[1] A protocell is a minimal, human-made, self-assembling package of lipids without DNA. Protocells have been developed in order to research the origins of life as well as the possibility of artificial life; researchers may use a bottom-up approach to their assembly that challenges the imperatives of DNA or they may engage in a top-down approach, starting with the simplest existing living cells and extracting the minimal set of necessary components for life as it exists today.[2] Driven by the organizing forces of chemistry and physics, protocells are created from nonliving matter but exhibit lifelike properties and are capable of interacting with each other and the matter around them. They can be engineered to manipulate targeted ecological situations because they inherently move through, respond to, and are ultimately capable of transforming their surroundings because of chemical interactions occurring at material boundaries in their environment.

With such performative abilities housed in a minimal entity, Armstrong foresees future wide-ranging applications of protocell technologies to include the cleaning up of pollutants in water systems, the detecting of human life under water, as well as the development of soft geological foundations that keep architectural structures from sinking and deteriorating in flood climates. Along with fellow architect Neil Spiller, Armstrong reasons: "Protocells inherently engage with the principles of design. They manipulate and can be manipulated to alter matter in their environment, reworking and repositioning this material in time and space—a strategy shared by life to avoid entropy

and decay towards equilibrium, in other words, death."[3] Without imitating or reproducing biological designs but instead exhibiting lifelike tendencies for survival, protocells can be programmed to modify both existing organic and inorganic systems across time. Leaving aside whether or not such large-scale ecological promises will actually come to fruition, such systemic manipulations are hypothetically possible because protocells share with living organisms a capacity for metabolism. Metabolism is the transfer of energy through chemical exchanges so that one kind of substance can transform into another. Engaging in collective metabolisms, protocells can be directed to move toward or away from another material or substance, leaving a physical trail. Protocell metabolisms are not accidental or random but remain dependent upon changing interactions between their relationally constitutive internal and external environments, since transformations

FIGURE 28. Protocell models. Rachel Armstrong at IDEA Laboratory, Venice, with Artwise Curators, 2015. Courtesy of Rachel Armstrong.

within one catalyzes transformations in the other. As metabolic material, protocells are symbiotic with the matter around them, chemically channeling various responses across multiple boundaries, forms, and sites (Figure 29).

Collective protocell metabolisms therefore present an integrated method of ecological renewal in which the protocell coexists and mutates with other surrounding matter, forms, and systems collaboratively, although not homogeneously, across time. Although protocells engage in chemical exchanges via human-directed and oftentimes synthetic manipulations, their contextual entanglements across multiple scales position these entities as acting within a larger systemic approach for self-repair. Inspired by a broader understanding of organisms, events, and evolution in terms of symbiosis, cooperation, and sacrifice, systems biology focuses on processes unfolding between forms rather than on their specific identification and labeling, therefore addressing dependencies that unfold between organisms, their cellular components, and their environment. From systems biology, we learn to pay closest attention to the interactions that catalyze living processes and that alternately vary and maintain the function of all manner of living entities. Biologist Lynn Margulis is credited with demonstrating that large evolutionary events in the history of life can occur as two or more seemingly differentiated things merge and cooperate, across small and large scales. In the late 1960s, she began to formulate her theory of "endosymbiosis," which emphasizes the heterogeneous cooperative existence of multiple organisms. Margulis suggests that the organs within a cell, or organelles, were once free-living, single-cell organisms that were engulfed by a host cell. The fusion of these two cell bodies also marks a fused function; Margulis proposes that the endosymbiont, living within the body of its host, evolved into an organelle over time, performing specialized functions that contribute to total cell function and survival.[4] The process by which such symbiosis occurs therefore complicates a clear determination of boundary relations and challenges us to decipher the uneven mechanisms of collaboration while questioning individual autonomous agency, as

FIGURE 29. Protocell models. Rachel Armstrong at
IDEA Laboratory, Venice, with Artwise Curators,
2015. Courtesy of Rachel Armstrong.

self-sustaining entities merge in favor of the sustainability of the co-operative project of metamorphosis, endurance, and evolution.

Although at first met by skepticism by the mainstream scientific community, her endosymbiotic theory is now widely accepted and has even catalyzed more recent understandings of human genome composition. Rather than focusing on independent mutation and evolutionary selection, Margulis has consistently over the course of her career foregrounded symbiotic relationships between all levels of organisms, from different phyla to different kingdoms, as the forces that drive, vary, and sustain life.[5] For Eugene Thacker, such thinking reroutes processes of identification and processes of relational interaction. "A first step in any system-based approach," writes Thacker, "is to articulate the system, that is, to demarcate a boundary. The second step is to complexify the first step by articulating the components and relationships that constitute that boundary. The tension that systems biology brings to the fore is whether this second step may in some sense fold back on the first, making the first step of identification biologically irrelevant."[6] What drives a system is, therefore, recursive; in demarcating identifiable things via boundaries, we articulate relationships, which in turn remark the boundaries that identify things. In recognition of Margulis's understanding of biological systems, we can then change the emphases of these determinations by first acknowledging ongoing relationships in order to then momentarily demarcate increasingly ambiguous formations. By compromising any clear-cut sense of autonomy, systems biology demonstrates that there can be no clear mutuality within any kind of encounter, so as to call attention to the variable alignments and uneven partnerships through which living forms persist and evolve, consistently recalibrating not only the forms and relations but also the systems of dependency. And now, as explorations with protocells demonstrate, these dependencies through which processes of evolution occur can, and should, be extended to encompass not only living but nonliving matter as well, in effect bringing systems biology in dialogue with synthetic biology.

In fact, a symbiotic system of exchanges between both living and nonliving forms drives Armstrong's proposal for the production of

architectural skins and structures induced through metabolic chemical interactions and subcellular properties of self-assembly and repair. Toward this end, Armstrong has been exploring the protocell growth of a limestone reef to stop the city of Venice from sinking. At the 2011 exhibition *Synth-ethic* at the Natural History Museum in Vienna, she presented her ongoing research as a *Living Chemistry* art installation along with the film *A "Natural History" of Protocells*.[7] Later shown in 2013 at the *En Vie* exhibition at Espace Fondation EDF in Paris as her *Future Venice* project, Armstrong's experiments with protocell metabolism seek to develop new material deposits that would eventually be capable of supporting the underwater wooden framework of the city.[8] She noticed that clams, mussels, and barnacles living within and along the Venice canals transform carbon from their environment into a limestone-like material; in her proposed project, protocells could be synthetically developed to do very much the same kind of work alongside these living creatures underneath the floating city.[9] Engineered to gravitate toward and coalesce across the city's submerged wooden foundations, these protocells would have the ability to metabolize carbon in order to shed mineral deposits like limestone because of targeted chemical responses.[10]

Intervening into existing ecosystems, then, a protocell is inextricably embedded in, controlled by, but also capable of managing its microsurroundings. For Armstrong, such capacities enable this synthetic chemical bundle to be "more than environmentally friendly—a benign state of being—but environmentally remedial—active and subversive."[11] Yet protocell metabolic processes require particular situational conditions in order to catalyze the human-intended outcomes. Martin Hanczyc, an avid proponent of protocell technologies and a chemist who has worked with Armstrong, qualifies the active potential of these lifelike bundles by suggesting: "The challenge for the designer, then, is to create not only the life-like structure, whether it be a chemical protocell or living building, but also the correct environmental context."[12] Indeed, protocells operate as chemical systems driven by reactions that are dependent on circumstantial physical matter, processes, and effects.[13] So the very functional goal of biotechnologically

developing and implementing protocells is to control these chemical reactions by manipulating chemical systems in controlled and targeted geophysical sites in order to offer the correct situations for both protocell sustainability and chemical transformation. This means that we humans provide the initial catalyst for ecosystemic sustainability and, by extension, ecological evolution.

Armstrong and Neil Spiller, in their manifesto "Against Biological Formalism," laud such a human-led directive:

> Protocell technology offers an opportunity for architects to engage with the evolutionary process itself. Unlike natural biological systems that evolve randomly according to Darwinian evolution, protocell technology allows deliberate and specific interventions throughout the entire course of its coming into being. By moving and metabolizing, protocells may form the basis for a synthetic surface ecology.[14]

Both claim a central role for architecture as they imagine the natural and built world renewed by way of these targeted protoliving surfaces growing with, into, and ultimately healing a range of hybrid biological and abiological forms. While the two architects emphasize the pure potentiality of a protocell, the contestable stakes of such a distinctly human-led intervention highlight one kind of response to self-correct our disastrously problematic current geological moment. Identified by atmospheric chemist Paul Crutzen over a decade ago now, the Anthropocene is marked by the dominance of human activities and our remarkably irreversible effects on the geophysical world—meaning that we have already induced and are now bearing the catastrophic effects of our evolutionary interventions.[15] In anthropocentric terms, then, a synthetic ecology may not be speculatively on the horizon but already unfurling its reaches in ways that are becoming ultimately uncontrollable. If we frame Armstrong and Spiller's rationale for remedial environmental repair within these terms, we could then explain their desire to develop an ecological system that evolves predictably by way of programmable components as one possible method to contain, manage, and ultimately save the human-built and inhabited world from

human-led collapse. The end game would be long-term environmental self-sufficiency catalyzed by directed self-repair—a proposed corrective that marks an attempt to mitigate anthropogenic disasters via anthropogenic means. Once the human-developed catalyst is actuated in situ, that particular environment could then potentially self-heal over time, again according to a program framed by our own human intentions. So against biological formalism, then, is a turn toward tactically manageable ecosystems that are both living and nonliving, functionally integrating engineered processes within biological ones and expanding biological ecosystems to include human-directed synthetic ones, seeing as the two are already inextricably entangled.

SYSTEMIC ALLIANCES

For the artist-architect Philip Beesley, systemic networks of organic and inorganic, living and nonliving matter instead often resist any expected outcome that we humans could determine in advance. In the mid-1990s, Beesley began developing geotextile installations that function as a type of synthetic surface ecology advocated by Armstrong and Spiller but without complete recourse to human-led programmability. In an earlier moment in his evolving practice, Beesley collaborated with a glass artist, Katherine Gray, to create *Synthetic Earth* (1996), a netted construct composed of wire strands, links, and barbs holding wax-sealed glass vessels containing a dark liquid combination of blood, bile, fermented soy, and salt solutions (Figure 30). With a mix of organic and synthetic materials assembled into what Beesley describes as a "tangled shroud," this densely irregular geometric matrix suggests an ambiguous and alternative ground for the nonhuman fostering and disintegration of both living and nonliving matter.[16] Beesley explains: "I'm trying to conceive of a layer of earth that is not at the service of humans but perhaps can have a mutual relationship with our own occupation"; his irregularly meshed and tessellating growths "have their own agenda, they need to feed themselves, they dig into the earth, they push humans away, they need to eat and digest and forge themselves."[17] In effect, these synthetic tessellations are unbounded

FIGURE 30. *Synthetic Earth.*
Copyright Philip Beesley (1996).

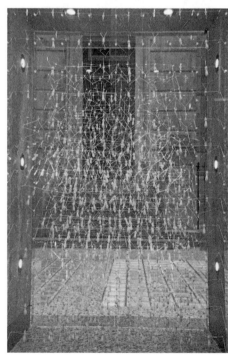

FIGURE 31. *Hungry Soil.* Copyright
Philip Beesley (2000).

and uncontrolled, serving to foster various collusions of living and nonliving matter in, around, and under us, with impulses and forces of their own that are distinctly not within our control and that do not operate according to our demands. Beesley describes his *Hungry Soil* (2000), for example, as "carnivorous," its artificial stainless steel matrix holding latex bladders that incessantly capture and ingest passing matter (Figure 31).[18] These three-dimensional, disarrayed, synthetic scaffolds create multiple layers of earth, surface, and soil, and yet they do so "through decidedly unearthly means," as Geoff Manaugh notes (Figure 32).[19] Here, earthly and unearthly, biological and abiological, living and nonliving actions, programs, and outcomes become enmeshed, the boundaries between a variety of material structures discordant yet interwoven.

Since 2007, Beesley's explorations into such hybridized and responsive geotextiles have produced an ongoing series of synthetic soil matrices titled *Hylozoic Ground,* which have been exhibited at the 2010 Venice Biennale of Architecture and the 2012 Biennale of Sydney,

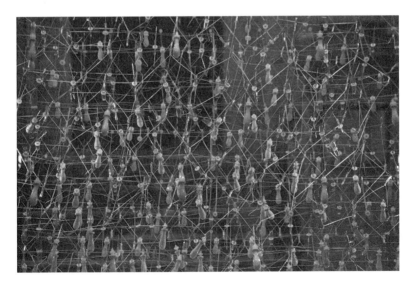

FIGURE 32. *Hungry Soil*, detail. Copyright Philip Beesley (2000).

among other venues. The work takes its name from the ancient Greek doctrine of hylozoism (from the Greek for *hyle*/matter and *zoe*/life), which forwards the notion that all matter, across all scales and forms, is living to some degree. The seventeenth-century Cambridge Platonist Ralph Cudworth introduced the term as a polemical contrast to soul-body dualism and reductive materialism. In the nineteenth century, Ernst Haeckel conceptualized a materialist hylozoism, proposing that all organic and inorganic matter was unified with similar behavior, causes, and laws, thus rendering the distinction between living and nonliving things null.[20] Akin to but unlike vitalism's emergent and or-ganizing tendencies, this later hylozoism instead purports the erasure of distinctions between all elements, solids, liquids, and gases. For their part, Beesley's matrices give rise to a disarray of uneven encoun-ters between a wide range of materials that move with and against each other, every thing potent, forceful, and charged, and yet signifi-cantly without final form, outcome, or, indeed, human intention.

Combining nonliving with wet biological systems, the suspended *Hylozoic* environment draws up and accumulates matter from its sur-roundings, swallowing and digesting a variety of things while meta-bolically transforming (Figure 33). Distributed throughout a diagonally gridded scaffold truss, *Hylozoic Ground's* lashes, pores, and whiskers alongside its swallowing actuators, glands, and probes sense and cir-culate air and matter throughout the environment in a feedback loop within and outside of the meshed canopies. Human motion is also tracked and read by multiple kinetic sensors, initiating a chain of re-sponsive reactions catalyzed by microcontrollers within this compo-nent assemblage.[21] Inculcated within this mechanized system are clusters of incubators, flasks, membranes, and islands carrying liquid-supported protocells and chells, developed by Beesley's collaborator, Rachel Armstrong. The incubators host collections of protocells gen-erated from water molecules in an oil environment that interact with both iron-based and copper-based minerals in order to undergo meta-bolic changes. Protocell-filled flasks of water capture carbon dioxide in order to catalyze these metabolic reactions, and in time this results in

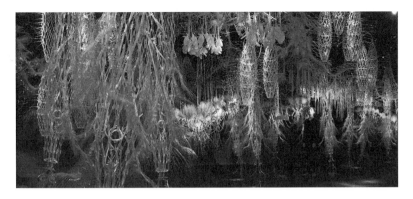

FIGURE 33. *Hylozoic Ground.* Copyright
Philip Beesley (2010).

mineralized deposits and vesicles that become minute structural scaf-
folds. In addition, membranes constructed of inorganic chells expand
and contract in relation to the variable hydration state of the entire
environment; chells are chemical cells with inorganic semipermeable
membranes that actively engage in chemical exchanges in a similar
way to protocells. Finally, integrated islands of glycerin and latex vials,
sea salt, and dried lavender draw out moisture to create a humid atmo-
sphere that respires and condenses over time.

Each layer provides the initial conditions for material growth, vari-
ation, and mutation, but the system as a whole develops in an ongoing
rhythm as each component's transformation begins to influence an-
other, allowing for the evolution of new materials and structures that
in turn generate unforeseen alliances between physical and chemical
variables within the total environment. Encouraging adaptation and in-
viting disruption, the complex layered matrices asymmetrically instigate
material fluctuations that establish the dynamic foundation necessary
for this systemic unpredictability over time. *Hylozoic Ground's* openly
dispersed ecologies are specifically driven by encounters between or-
ganic and inorganic components, each collaboratively affecting the con-
ditions of the other across time.

Within these matrices, and as a variety of matter comes into and

out of contact with and beyond our bodies, identifiable boundaries within and outside of the living are constantly in flux. Writing about *Hylozoic Ground,* Cary Wolfe suggests:

> Paradoxically, these radically inhuman and nonorganic programs, codes, and archives are the medium through which we can fully realize who we are—but only by becoming something we are not. In this light, the uncanny effect of Hylozoic Ground is that rather than confronting us with the question, "Is it alive?", it confronts us instead with the dawning realization, "Are we?".[22]

As the layered networks actively displace the centrality of both human form and function, these matrices also confuse distinctions between the living and the nonliving. In fact, such an open ecological system ultimately recalibrates our prioritizing of life, carrying out material symbioses between a range of forms-in-the-making that altogether de-centralizes our very human bodies, directives, and positions.

TOWARD THE NONLIVING

While vitality emerges within Beesley's structural installations as al-located and dispersed among a range of nonhuman agents and non-living matter, in attending to agential vital matter as humans we still often tend toward biological descriptives and endless potentialities, veering instinctively toward the qualifications of the living and ex-tending the exceptional capacities of life into nonlife. But what if, in decentralizing human directives as well as recognizing the necessity of nonliving forces and formations as integral to life both according to and beyond the human, as I am arguing that Beesley's work urges us to do, we also decentralize the capacious formulations of the biologi-cal? This sort of question threatens to depart from the working frame-work of this book; however, it is important to at least momentarily acknowledge nonlife as neither fully separate nor necessarily distinct from processes of forming life.

In her recent work, Elizabeth Povinelli suggests that the scope and current usefulness of biopolitics, with its focus on life (as birth,

growth, reproduction) vs. death, has become limited. Instead of maintaining boundaries between what does and does not count as life, she argues for a wider refocusing on what she calls "geontological power" or "geontopower" as that which considers nonlife along with life while encompassing assemblages of form and matter beyond life/nonlife categories altogether.[23] To this end, Povinelli outlines four geontological principles that, without remaining abstract, are grounded in her ethnographic work with the Karrabing, an indigenous people living in northwest Australia:

1. Things exist through an effort of mutual attention. . . .
2. Things are neither born nor die, though they can turn away from each other and change state.
3. In turning away from each other, entities withdraw care for each other. Thus the Earth is not dying. But the earth may be turning away from certain forms of existence. . . .
4. We must de-dramatize human life as we squarely take responsibility for what we are doing. This simultaneous de-dramatization and responsibilization may allow for opening new questions. Rather than Life and Nonlife, we will ask what formations we are keeping in existence or extinguishing?[24]

So instead of upholding distinct borders between things that are born and those that are dying, and between things that are living and nonliving, we are asked to witness how attention and care are directed between things in their current state or, put another way, how the dependencies between those things unfold and are kept in play. And when the current state of each thing shifts, as it always will do, so shifts the attention and care of each thing away from the other and toward something else. Life, especially human life and with it death, therefore no longer becomes the focal point of existence but rather one state among many. In order to dedramatize human life, we are presented with the task of abandoning the precarious drama of finitude that upholds life/nonlife distinctions, since dying is inapplicable to and for the nonliving. If we decentralize life and its divergence and difference from nonlife, and if we displace the biological and with it finitude and death, we also have to

decentralize the endless potentiality of the ever-emergent vital impulse as defining life and instead turn toward the temporal endurance of physical matter across various states. To follow Povinelli's thinking, the relinquishing of life's endless potentiality—where to potentiate is inevitably to extinguish—necessitates a turn toward the material actuality of otherwise biological, geological, ecological, and cosmological arrangements. Actuality is, then, a refusal of potentiality that nonetheless still attends to both living and nonliving matter's continuous adjustments as well as their transitions toward other instantiations over time.

By bringing Povinelli to bear on the explorations undertaken by Armstrong and Beesley, we are entreated to consider the material co-implication of living and nonliving systems as they coalesce through ongoing acts of heterogeneous cooperation and sacrifice where actual material states inevitably and interconnectedly shift. In acknowledging the contingent ways in which these acts unfold and how they metabolize more to come, we can begin to see how biologically living entities, inorganic substances, and inanimate structures cannot be held so far apart from each other, cannot be completely fixed, bound, or contained, that all are energetic tendencies or forces that transform by way of each other. These ecologies of evolution and metamorphosis are symbiotically volatile and unconfined, predicated upon material partnerships in which mutuality is never offered and reciprocities are never evenly given. Without being able to enforce stable boundaries between entities, we may be moved, quite uncomfortably in most cases, to loosen our grasp on predetermined teleological purposes and fixed outcomes of any living system, since we enact but one part of the collaborative impacts between living and nonliving matter. Even if we continue to intervene into such ecologies, we should at least be aware of how multiple systems act outside of the potentiality of our targets and goals. Our difficult challenge going forward, then, is to continuously reassess our unstable surroundings and, by extension, the direction of our attention and care, turning toward the unintentional material exigencies of both life and nonlife that exceed any corrective narrative of environmental self-sufficiency and repair, including but most emphatically beyond our own.

VITAL REGENERATION

The Promise and Potentiality of Stem Cells

A young ponytailed girl sits cross-legged on a carpeted floor surrounded by six fleshy indeterminate forms, each with varying hints of veins, vertebrae, and orifices, and each one covered in mottled pinkish skin. She smiles happily down at these enigmatic objects under her care, carrying one as it nestles and bulges over her arm, and placing her hand on top of another. Although they are all composed of silicone and polyurethane, including the girl, each form appears arrested in breath and movement; the amorphous, unidentifiable, lifelike lumps seem to be paused between taking in and letting out air, slinking, folding, and cuddling, suggesting a brief window into the girl's role as caretaker of this odd playgroup (Figure 34). Patricia Piccinini's *Still Life with Stem Cells* (2002) is a still life not of our existing but rather of our imagined potential life.[1] Exhibited multiple times but perhaps most prominently as a part of Piccinini's Australian pavilion exhibition at the 2013 Venice Biennale, the work offers both a stillness and a life beyond the cusp of the already known, in which ambiguous living forms grow unrecognizably and unrelentlessly in tandem with and under the supposedly watchful guidance of us humans. With the isolation and culturing of the first human embryonic stem cell line by James Thomson at the University of Wisconsin in 1998, the birth of the cloned sheep Dolly a couple years prior, as well as the consistency and normalization of in vitro fertilization treatments, Piccinini's tableau depicts an outlay of a possible future, welcome or not, in which unforeseen alliances

115

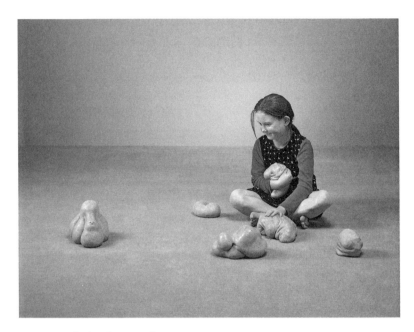

FIGURE 34. *Still Life with Stem Cells*, Patricia Piccinini, 2002. Silicone, polyurethane, human hair, clothing, carpet, dimensions variable. Courtesy of Tolarno, Roslyn Oxley9, and Hosfelt Galleries.

between forms of pre- and remanipulated living matter extend across multiple renewable temporalities of life.

Ten years later and that future is becoming our present. In 2012, the artists Guy Ben-Ary and Kirsten Hudson first presented their work *In Potentia* as a part of the exhibition *SOFT CONTROL: Art, Science, and the Technological Unconscious* in Maribor, Slovenia, and then subsequently at the 2013 *Semipermeable (+)* exhibition, curated by Oron Catts at the Powerhouse Museum in Sydney, Australia.[2] Ben-Ary and Hudson had been working with a new stem cell technology that reverses and re-engineers a cell's developmental pathway. Using mouse cells in 2006 and human cells in 2007, cell biologist Shinya Yamanaka introduced a method to create what he called "induced pluripotent stem cells" or iPS cells—a process through which an adult cell is re-

programmed and dedifferentiated back into an embryonic stem cell state and then redifferentiated into a new type of cell.[3] As artist residents at SymbioticA, Ben-Ary and Hudson purchased foreskin cells from an online cell bank and worked with Stuart Hodgetts, director of the Spinal Cord Repair Laboratory at the University of Western Australia, to reverse engineer their cells back into stem cells and then to differentiate them into neurons that actually function as a neural network. They then collaborated with Mark Lawson, coordinator of product and furniture design at Curtin University, to build a conical wooden container with a semispherical glass top, within which the neurons were placed, while below, a custom bioreactor kept the neurons alive and firing. This display capsule, inspired by the form of eighteenth-century scientific paraphernalia, also housed a multielectrode array that converted the electrical activity of the neural network into an audible sound output—a thickly layered, crashing, whoosh of static sound (Figure 35).[4] Ben-Ary and Hudson's infamously nicknamed "dickhead" reroutes both the formal and temporal passages of cells, tissues, organs, and bodies toward the infinitely possible and exchangeable. If foreskin cells can become neurons and those neurons can connect and interface with each other and transmit electrical signals, then any stable functional pathway of biological matter can be replaced, reversed, and regenerated.

Situated within two very different moments in stem cell science, these artworks activate biological potentiality while requalifying life, and by extension death, as now indeterminately malleable within nonlinear time. The potentiality of embryonic stem cells lies in their inherent pluripotency: the ability to differentiate into any kind of cell and tissue in the body, along with an unending capacity for self-renewal. Embryonic stem cell lines halt and suspend this moment of pluripotency, expanding the possibility of endless plasticity of form and function in a convoluted temporality that conflates past with future. While the last chapter considered systemic symbioses between living and nonliving matter as necessary for the transformation and evolution of biological formations significantly beyond the biological, this chapter

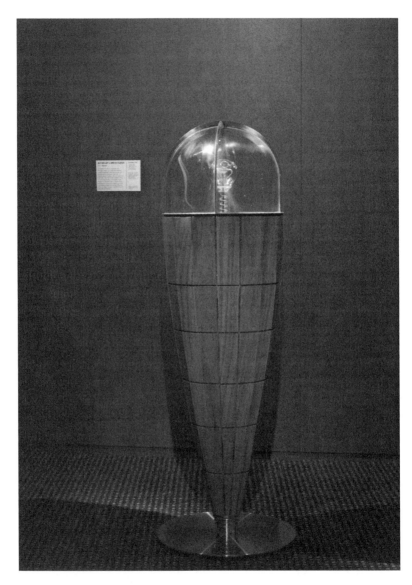

FIGURE 35. *In-Potentia*, Guy Ben-Ary and Kirsten
Hudson, 2013. From the *Semipermeable (+)* exhibition,
Power House Museum, ISEA, Sydney, Australia.
Photograph by and courtesy of Guy Ben-Ary.

addresses the capacity for formal and functional regeneration outside of living and dying time. Bringing the lab into the gallery, art practices can present the strange potentiality of renewable time materialized in and as action, in circumstances where there is no need for practical disease modeling or treatment plan. While making legible the various infrastructures, contexts, and systems of dependency necessary for regeneration within revisionary time, Piccinini's and Hudson and Ben-Ary's projects offer unexpected objects and disjunctive experiences that arise when life is endlessly renewed within temporalities beyond those of life and death.

DEFINING STEMNESS

A stem cell can be defined most simply as an undifferentiated cell that has the capacity to develop into other cell types—blood, muscle, skin, nerve, and so on—and to make copies of itself, dividing into a mother cell that is identical, and thus undifferentiated, and a daughter cell that is differentiated. Adult stem cells, found primarily in later stages of development, replete the cells of a specialized system; so, for example, blood stem cells differentiate into blood cells. Adult stem cells are therefore qualified as multipotent, since their ability to differentiate is particularly associated with the tissues and organ systems in which they are located. In 1988 at Stanford University, Irving Weissman isolated and cultured the first blood, or hematopoietic, stem cell from the bone marrow of a mouse; in subsequent years, Weissman would also be the first to isolate an adult human hematopoietic stem cell, a human neuronal stem cell, and a human leukemia stem cell.[5]

In contrast to adult stem cells, embryonic stem cells are found during the blastocyst stage of early development formed only a few days after fertilization and prior to implantation in the uterus.[6] Embryonic stem cells, derived from the inner cell mass of a blastocyst, are defined as pluripotent because they give rise to every type of cell in the body, along all three germ layers: the ectoderm (skin, nerves, and brain), the mesoderm (bone and muscle), and the endoderm (lungs and digestive system), in addition to producing the germline (sperm and eggs).[7] In

1981, Gail Martin at UC San Francisco, and Martin Evans and Matthew Kaufman at the University of Cambridge, working independently of each other, first isolated and cultured mouse embryonic stem cells.[8] Then in 1998 came a breakthrough: James Thomson and his team at the University of Wisconsin–Madison became the first to isolate and culture human embryonic stem (hES) cells, after having done so with embryonic stem cells in rhesus monkeys in 1995.[9]

While embryonic stem cells in particular are inextricably tied to late twentieth- to twenty-first-century bioethical debates surrounding the definition of life, debates that affect and often reroute the development of stem cell science, the terminology and notion of a stem cell actually first appears during the later part of the nineteenth century in relation to the origin and regeneration of the germline (with its inheritable genetic determinants) and the hematopoietic (or blood) system.[10] The German biologist Ernst Haeckel used the term *Stammzelle* as early as 1868 in his studies of evolution in order to identify a kind of unicellular organism from which all multicellular organisms arose, and in 1877 he proposed that the fertilized egg was a stem cell. Later in the century, the term referred specifically to a type of embryonic cell from which develops other specialized types of cells. In 1885, August Weismann's theory of the germplasm proposed that germ cells containing genetic and inheritable determinants were segregated during embryonic development and remained separate from other somatic cells that carried out particular functions of the body. In the few years that followed, two other embryologists, Theodor Boveri and Valentin Haecker, isolated these early germ cells deemed capable of transmitting genetic information across generations.[11] In 1896, in reviewing both Boveri's and Haecker's work, Edmund B. Wilson utilized the English-language term *stem cell* to refer, as Boveri and Haecker had understood, to the unspecialized germ cell that gives rise to the germline.[12] Around the same time, a handful of scientists researching the regeneration of the blood system believed that there was a common precursor to all types of blood cells. Beginning in 1896 and continuing through the turn of the century, Artur Pappenheim, Alexander Maximow, Wera Dantschakoff, and Ernst Neumann adopted the term

stem cell to identify this common progenitor.[13] What is important to note across this early history is the burgeoning understanding of a stem cell's innate properties in tandem with a growing acknowledgment of the functional variabilities between embryonic and adult stem cells.

From adult to embryonic and multipotent to pluripotent, stem cells today can be qualified either according to where they are found or according to what extent they are able to develop into other cells and tissues. As bioethicist Insoo Hyun clarifies:

> The terms *embryonic* and *adult* signify the origins of the stem cells in question. The terms *pluripotent* and *multipotent* signify the capabilities of stem cells—that is, whether they are able to differentiate into all types of cells or a more limited range. Because these two pairs of terms signify two different aspects of stem cells— where they came from and what they do—we must not assume that the terms *embryonic* and *adult* can be used synonymously with *pluripotent* and *multipotent*.[14]

Hyun argues in favor of terminologies acknowledging capabilities over those describing origins in order to sidestep the politicized status of the embryo, particularly avoiding the misguided view that adult stem cells are only found in adults (since they can also be found in fetuses) and that embryonic stem cells exist in growing fetuses (since they only can be extracted within a short framework of a few days prior to the fertilized embryo's implantation in the uterus).[15] And, by qualifying stem cells according to what they do, significant emphasis is placed on their operative potential made possible by biotechnological intervention and maintenance, with an eye to future possibilities instead of past history.

As we know so well by now, the definition of embryonic stems cells and the origins of their procurement have always been embroiled in politics, while research into their functionality is closely dependent upon the current nature of the changing political landscape. Here in the United States when President George W. Bush took office in 2001, he banned federal funding of research on newly derived stem cells lines, which meant no government support went toward the culturing

of human embryonic stem cells from discarded embryos developed by IVF clinics (embryos that were no longer needed by couples undergoing treatment and that were destined to be destroyed). Bush's restriction underscored an earlier bill proposed by House Representatives Jay Dickey and Roger Wicker (Republicans from Arkansas and Mississippi, respectively) that was passed in 1996 under President Clinton with pressure from antiabortion groups and the right to life movement. The Dickey-Wicker Bill declared that "federal funds may not be used for the creation of a human embryo for research purposes or for research in which a human embryo is destroyed, discarded, or knowingly subjected to risk of injury or death that would be greater than the risk allowed for research on fetuses *in utero*."[16] Because of these federal restrictions spanning from President Reagan through Clinton and onto George W. Bush, stem cell research primarily became privately supported through large biotechnology companies. So when James Thomson cultured the first human embryonic stem cell line, he did so in a lab completely kept separate from the one used for studies supported by the National Institutes of Health, and his funding came from the Geron Corporation in Menlo Park, California. And because he used private funds, he owned the hES line he created, turning patent rights over to the University of Wisconsin's Alumni Research Foundation (WARF) while Geron retained the right to develop the stem cells as blood, bone, pancreas, liver, muscle, and nerve cells to advance research into treating diseases in those areas.[17] Stem cell research was thus intricately shaped and shared according to the shifting nature of who could fund what, while remaining within the private and for-profit domain until March 9, 2009. On that day, surrounded by key stem cell scientists including James Thomson, President Obama signed a new Executive Order allowing federal funding to support the use of discarded IVF embryos to obtain stem cells for further research.[18] With the inauguration of President Trump, who has not made his position clear although his vice president Mike Pence is most certainly a staunch opponent, stem cell research in this country could very well once again be cut off from governmental support.

Yet throughout all of these public restrictions that force research

into the private sector, we still do not have a stable hold on stem cell identification and functionality, especially the pluripotent embryonic variety. As medical anthropologist Linda Hogle makes clear: "Human embryonic stem cells are elusive, recalcitrant entities that resist characterization and standardization" with their "distinct, cumulative identities" that change according to the specific lab environments in which they are grown.[19] Hogle aims to unveil as misinformed the general public's understanding of human embryonic stem (hES) cells as consistently malleable, easily directed, and completely interchangeable. Instead, she argues that hES cells are incognito, transient, can resemble other things, and have the tendency to keep differentiating rather than remaining pluripotent, "in part because hES cells as such do not exist in nature (in vivo); rather, they are created in the laboratory and through the definitional moves of those scientists who isolate and culture them."[20] Pluripotency is therefore problematically unstable and momentary; the pluripotent "stemness" of hES cells is fleeting, since their impulse is to move swiftly onto differentiated cells and tissues. Additionally, stem cells share with cancer cells the capacity to regenerate, so oftentimes surrounding tissues signal embryonic stem cells to die off (a process of cell death called apoptosis). As one researcher, who Hogle interviewed, states: "It's risky to be pluripotent." As another researcher explains: "What we have is real aberrant. It just doesn't exist. And people are like, well what does it do normally? Normally it becomes a human. Normally it exists for like two days."[21] Identifying hES cells by way of conventional markers and stages, in terms of cell form and structure (morphology) and physical or chemical characteristics (phenotype), becomes difficult since hES cells only exist for a very short period of time and thus must be suspended and sustained artificially along a quickly changeable pathway.

In fact, cultured stem cells cannot help but differentiate and a small percentage of differentiation is commonly admissible. Even the descriptive definitions used in favor of determining intrinsic properties are imminently variable, since terminology of undifferentiation, differentiation, and pluripotency are all vague and relative, dependent upon the results of particular tests that might predict functionality.[22]

Embryonic stem cells are identified by and tested for their future performances and potential capacities. These multiple tests, occurring over lengthy periods of time, include: growing stem cells across multiple cultures for many months to assure their capability for renewal over a long term; freezing, thawing, and replating them; determining the presence of transcription factors, which turn genes on and off and are associated with keeping the cells in an undifferentiated state; examining the cells to make sure the chromosomes have not changed over time; seeing if they differentiate spontaneously in culture; manipulating them so that they will; and, finally, injecting the cells into an immune-suppressed mouse to see if they differentiate into a teratoma, a benign tumor containing all three germ layers, which indicates that the cells are pluripotent.[23]

During the long amount of time that it takes to complete these tests to determine whether the stem cells in question are indeed acting like stem cells and will presumably do so into the future, and alongside continuous monitoring and manipulation within lab conditions, the cells are also beginning to adapt to the very conditions of their testing. As Hogle describes:

> In routine procedures, cells are cultured to the point when they produce viable colonies, then cells from the colonies are divided out (called "picking") and replated to keep them going (each time constitutes a "passage"). But this means the person picking the cells to reculture is aiding a type of natural selection in the lab. There is always the possibility that the cells that survive to the next passage are the ones that simply adapted well to that lab's particular conditions, not necessarily those that were intended to be perpetuated. . . . The ability to maintain embryonic stem cells in vitro has thus created a different kind of material object in an artificial environment that itself can change the properties of the cells.[24]

Embryonic stem cells are therefore simultaneously reliant on and symbiotic with their specific environment, both within and outside of their petri dishes, and in turn are produced and sustained through both biological and social relations that are inevitably variable over time.

SITUATING PLURIPOTENCY

Pluripotent stem cells, like all cultured cells, depend on the support of lab workers and lab environments as well as on the culture medium that provides the necessary nutrients to keep the cell lines alive and thriving, growing, and spreading over the surfaces of petri dishes under artificial situations and times. Such procedures routinely practiced today are indebted to early twentieth-century developments in cell culturing, detailed extensively by Hannah Landecker in her study on *Culturing Life*. As she outlines, in 1907 Ross Harrison established a method for maintaining embryonic frog nerve cells in vitro, and subsequently Alexis Carrel and Montrose Burrows, building upon Harrison, advanced a way to serially cultivate, or to culture and subculture, all manner of cells and tissues, introducing the phrase "tissue culture" in 1911.[25] Projecting forward from these developments toward the end of the twentieth century, stem cell researchers still had to figure out how to supply an appropriate feeder layer on which to grow and sustain the cells, or else once procured the cells just kept dying. When Gail Martin first isolated and cultured mouse embryonic stem cells in 1981, her breakthrough occurred because she started to grow the ES cells on a feeder layer of mouse embryonic fibroblast (MEF) cells, found in connective tissue and responsible for synthesizing collagen and extracellular matrix.[26] Irradiated so as not to divide and grow, these MEFs released the appropriate nutrients into the culture medium and provided a sufficient surface on which the mouse embryonic stem cells could attach. James Thomson would use this same feeder layer for culturing human embryonic cells in 1998, and the method continues to be implemented.[27] In the early 2000s, Michal Amit, Joseph Itskovitz-Eldor, and their team began to experiment with using human feeder cells, derived from human foreskin, and then subsequently a medium composed of a combination of specific growth and inhibitory factors that is free of feeder cells.[28] What we can take away from these experiments is that the capacity for pluripotency, or more specifically the capacity to harness pluripotency into the future, is not innately manifest but rather is intimately dependent on the context of surrounding cells that do nothing other than nurture and sustain stem cells, whose

biologically ephemeral and now continuously possible state of stem-ness has to quite literally be fed. And this dependency is symbiotic, as mouse retroviruses existing in the mouse embryonic fibroblast feeder layer can possibly spread to the human stem cells, which is why a human-derived culturing system is being explored, especially in cases where human stem cell therapies are a future goal.

So pluripotent stem cells are fed by other cells, but on a larger scale, they are also dependent on other established biotechnological processes that afford the isolation and procurement of embryonic stem cells in the first place. Serving as the enduring political point of conten-tion, human embryonic stem cells have mainly been derived from in vitro–fertilized embryos that have not yet been implanted but that have been deemed unnecessary or surplus by patients seeking treatment at in vitro fertilization clinics. As Sarah Franklin so incisively contends in *Biological Relatives: IVF, Stem Cells, and the Future of Kinship,* in vitro fertilization and stem cell technologies are now intricately linked, extending the already expanded understanding of biological relations instantiated within IVF practices into regenerative medicine's hope for human cell-based therapies. This extension, she argues,

> must be seen as an evolving technological platform, serving as a base for an expanding variety of human cell cultivation methods, which are in turn linked to the prospect of improved cellular replacement and repair. Human embryonic stem cell research is a direct offspring of the evolution of the IVF platform: it was derived from the same research on early mammalian development that enabled IVF to be used in humans, and is dependent on human IVF for the supply of research embryos necessary to the refine-ment of its clinical applications.[29]

While Franklin has written extensively about IVF technologies else-where, here she is interested in the intertwining of technologized repro-duction and regenerative medicine, as based in stem cell science, and, in particular, how reproductive substances are exchanged, retooled, and rerouted toward regenerative rather than reproductive ends. She goes on to suggest:

This new system of embryo transfer and human cell-based translation is an essential part of the equipment used to transform reproductive substance and to make it become differently productive—that is, to become pluripotent in order to be able to redirect cells to new commercial and therapeutic purposes. It is thus also here, in the interstices of codes and substance, that the meaning of "biological relations," and indeed of "biological relatives," is newly problematized.[30]

Regeneration is therefore biologically related to reproductivity or, more emphatically, the history of technologized reproduction which in itself has introduced new forms and practices of biological relatedness. At the boundaries between IVF and stem cell research (which for Franklin, writing about the stem cell lab at Guy's Hospital in London, occurred at an actual hole in the wall between an IVF clinic and a stem cell lab), the future of kinship is therefore also being retooled as embryos are transferred and recoded for nonreproductive purposes. Indeed, human embryonic stem cell research and regenerative medicine's hope for cell-based therapies are kin with IVF's practices of making kin.

If we return to Patricia Piccinini's *Still Life with Stem Cells* with Franklin in mind, we can see how this kinning of IVF and stem cell technologies is made palpable in Piccinini's familial arrangement of child and stem cells imagined as *ex vivo* scaled-up biomorphic forms (Figure 36). In this tableau, newly materialized kinship relations extend to biotechnologically reproduced forms and regenerated living matter; IVF has produced new biological kin, both in its reproductive capacity as well as in its affordance of new stem cell lines, and the outcomes of both offer an expanded range of biological relatives. If IVF makes human babies as well as human embryonic stem cell lines, then Piccinini's work urges us to pay attention to the unexpected consequences of such an entwinement. As these past and future biological and biotechnological forms become interrelated in Piccinini's art, a work like *Still Life with Stem Cells* provokes, as Donna Haraway suggests, "the onto-ethical question of care for the intra- and inter-acting

generations that is not asked often enough in technoculture, especially not about its own progenitors and offspring. The important question is not found in the false opposition of nature and technology."[31] Instead of opposition, we can turn to dependent relatedness, to trace lines of affinity between biotechnological matter, processes, and resulting forms, as depicted in the young girl's position next to these stem cells. With both Franklin and Piccinini in tow, then, the dependency of human embryonic stem cell lines on IVF embryos can be thought of in terms of biological relations of kin, in which the terms *biological* and *kin* are conditionally reliant on technological manipulations and temporal reprogramming of all kinds of living matter across nonlinear time.

Although IVF has been the primary source of human embryonic cells, another far less successful method that introduces its own set of challenging technological exceptions and kinship expansions is somatic cell nuclear transfer (SCNT), known popularly as cloning. During SCNT, the nucleus of a somatic or nonstem cell is removed and replaced by the nucleus of an oocyte, female germ cell, or unfertilized egg, which in turn can give rise to embryonic stem cells.[32] As early as 1958, John Gurdon at the University of Oxford published a paper in *Nature* detailing his work on reprogramming somatic cells in *Xenopus* frogs back to their embryonic state.[33] Decades later, influenced by Gurdon's work with nuclear transfer, Ian Wilmut, Keith Campbell, and their team at the Roslin Institute at the University of Edinburgh cloned the now-famous Dolly, born on July 5, 1996, from another adult sheep's somatic cell.[34] After the appearance of Dolly, President Clinton instituted a ban on federal funding to support the cloning of humans using this technique and asked the Bioethics Advisory Commission to consider future implications. The commission's subsequent report, published in June of 1997, recommended a continuation of the moratorium on federal support of any attempt to create a human child via somatic cell nuclear transfer but concluded that "no new regulations are required regarding the cloning of human DNA sequences and cell lines, since neither activity raises the scientific and ethical issues that arise from the attempt to create children through somatic cell nuclear transfer, and these fields of research have already provided important

FIGURE 36. *Still Life with Stem Cells*, Patricia Piccinini, 2002. Silicone, polyurethane, human hair, clothing, carpet, dimensions variable. Courtesy of Tolarno, Roslyn Oxley9, and Hosfelt Galleries.

scientific and biomedical advances." In addition, research into the cloning of animals could continue if "subject to existing regulations regarding the humane use of animals and review by institution-based animal protection committees."[35] Besides differentiating between human and animal life, the report importantly distinguished between reproductive SCNT—that allows reprogrammed embryos to fully develop into fully grown animals—and therapeutic SCNT—that is directed solely toward producing hES cells for patient-specific cell-based therapies.[36] Ultimately, however, political and popular disapproval of reproductive SCNT impedes much advancement in therapeutic SCNT, and the method has proven elusive in human cells (apart from Woo Suk Hwang and his team at Seoul National University, who in 2004 claimed to have isolated and cultured human embryonic cells from a cloned human embryo, a claim that was disproven shortly thereafter).[37] Nonetheless, Gurdon's method of reprogramming cells to revert back to their embryonic state would decades later influence the instantiation of embryonic stem cell pluripotency through another process of developmental reversal.[38]

INDUCING PLURIPOTENCY

In 2006, Shinya Yamanaka and his research team at Kyoto University discovered that they could reprogram differentiated mouse skin cells to act like embryonic stem cells by using retroviruses that would introduce stem cell–associated genes, or transcription factors, into the skin cells. They found that only four of these transcription factors would be enough to instigate pluripotency. Now commonly called the "Yamanaka factors," Oct2 and Sox2 produce proteins that help maintain embryonic stem cells, Klf4 inhibits differentiation and cell death, and c-Myc, a gene associated with cancer, aides in pluripotency and replication.[39] Yamanaka called these cellular reprogrammed cells "induced pluripotent stem" or iPS cells.[40] Like embryonic stem cells harvested from the inner cell mass of embryos at the blastocyst stage, Yamanaka's iPS cells were able to self-renew, differentiate into cells from all three germ layers, and produce teratomas (benign growths

containing cells from all three germ layers) when injected into immu-nodeficient mice, all of which indicate the capacity for pluripotency. The following year, Yamanaka's team, as well as another working independently and led by James Thomson, applied the same method to human somatic cells to produce human iPS cells.[41] Subsequently, in 2010, Derrick Rossi and his team at Harvard University replaced the viral vectors carrying Yamanaka's four transcription factors with synthetically modified RNA vectors in order to avoid the possibility of integrating viruses into and mutating the genome.[42]

As with Gurdon's breakthrough in somatic cell nuclear transfer, Yamanaka's development of induced pluripotency opens up a two-way developmental path capable of moving both forward and backward in time and thus of revising pluripotency's plastic retooling of form with a plastic reprogramming of temporality. Plasticity of both form and time has always been at the heart of cell and tissue culturing techniques, for, as Hannah Landecker contends, "the reshaping of cellular living matter has been linked step by step to a manipulation of how cells live in time. . . . Techniques of plasticity are modes of operationalizing bio-logical time, making things endure according to human intention."[43] We manipulate cells as well as the medium in which they exist, isolat-ing and suspending them, and we do so in order to variably develop and differentiate them on our own particular cue. Therefore, as bioethicist Insoo Hyun explains, "we find ourselves directly confronted with the realization that the full capabilities of stem cells are socially, not just biologically, determined."[44] Now with a method to induce pluripotency, we can not only advance but also reverse cells in time and, as always, on our cue, dedifferentiating them back into embryonic stem cells and then redifferentiating them into any number of other cell types. Suspension of developmental form along with the capacity for endur-ance in suspended time coincide to offer the possibility of conflating a future potential with the potentiality embedded in earlier developmen-tal stages now existing in that cell's past. Put another way, with iPS cells, pluripotency is afforded through factors that offer malleable and revisionary time. Instead of a reliance on IVF or SCNT, each provid-ing embryos at the perfect stage to harvest embryonic stem cells from

their inner cell masses and as such winding up in long political and legal oppositions, iPS bypasses the need to procure human embryonic stem cells and instead biotechnologically reinstigates that very embryonic stage inherent and already past in an adult cell and then allows that cell to develop along a completely different pathway. With the advent of iPS cells, we can now engineer pluripotency, its exceptionalism having been both descriptively and functionally extricated from the potentiality of an externally sourced embryo.

Bringing the induction of pluripotency out of the lab and into a different public forum, Guy Ben-Ary and Kirsten Hudson's artwork *In Potentia* leaves open the future potential of the iPS cell's already harnessed potency. Reprogramming foreskin cells back into embryonic stem cells and then onto functioning neurons that network to produce audible activity, Ben-Ary and Hudson reverse engineer a biological brain, which challenges our accepted notions of what qualifies as human life and, by extension, allowable death especially, if like almost all biological art, this neural network ultimately faces its own end upon the close of the exhibition (Figure 37).[45] Such an artwork utilizes technologies developed for regenerative biological purposes in an exploratory manner and in doing so also calls into question the endgame of biological renewal. What, then, if not a living person, does this resulting human neural network enact? What kind of living entities do induced pluripotency help to engineer, if Ben-Ary is now also reprogramming his own skin cells to develop his own alternate neural network embedded in an alternate form in order to "re-embody himself"?[46]

Starting in 2013, Guy Ben-Ary began developing a new work with iPS cells, deriving his skin cells from tissue taken from his arm, sending those fibroblasts to the Pluripotency Lab at the University of Barcelona where he worked with Mike Edel to reverse engineer them into embryonic stem cells and then onto neural stem cells, which were frozen and shipped back to Perth so Ben-Ary could then differentiate them into neurons (Figure 38). Making its first appearance in October 2015 in Perth and then in Sydney, Australia, *cellF* is a functioning neu-

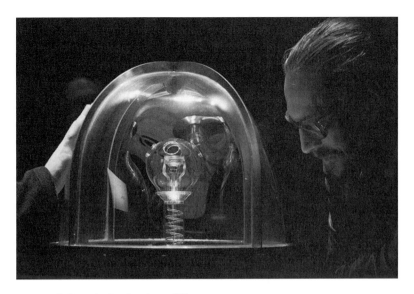

FIGURE 37. *In Potentia*, Guy Ben-Ary and Kirsten Hudson, 2012. From the *Soft Control* exhibition, KIBLA, Maribor, Slovenia. Photograph by Where Dogs Run. Courtesy of Guy Ben-Ary.

ral network, sourced from Ben-Ary's own cellular matter, that lives within another bodily form. Shaped like a large gramophone amplifier, this sculptural body was designed and constructed by the artist Nathan Thompson, complete with custom-built biological lab and sterile hood (Figure 39). The process of developing *cellF* was a lengthy and complicated one involving not only the inducing of pluripotent stem cells and their differentiation as neurons but also the development of an interface that could interact with the electrophysical impulses (Figure 40). The dishes that host Ben-Ary's firing neural network contain a grid of electrodes capable of both recording the neurons' electrical signals as well as stimulating them. Music from live musicians could be sent to the neurons as electrical stimulation and the neurons' response in microvolts was amplified and sent to an analogue modular synthesizer, creating an improvised sound piece. Andrew Fitch, an electrical engineer, designed the interface between external sound

source, neurons, and synthesizer. Up to eight microphones could pick up sounds made by live musicians that were then used to electronically activate the neurons via a hardware program designed by Nathan Thompson. The response came in two forms: a neuron's action potential and neural noise. This output was then dispersed across sixteen speakers placed throughout the performance site, and audience members were encouraged to walk through this spatialized call and response (Figure 41).[47]

The sheer and eerie feat of hearing Ben-Ary's out-of-body neural network, the cellular *cellF* to his self, is underscored by the liveness of performance, which allows us to witness his regenerated living matter act and react in real time. Through this performance, our own differentiated bodies are placed in concert with the redifferentiation of Ben-Ary's cells and his reallocated *cellF*, catalyzing a variety of unforeseen

FIGURE 38. *cellF*. Ben-Ary's stem cells differentiating to neurons at day eight of the process, SymbioticA labs, UWA. Photograph by and courtesy of Guy Ben-Ary.

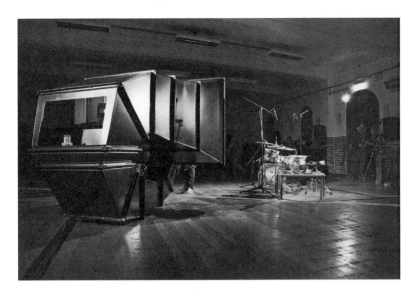

FIGURE 39. *cellF*, 2015. Masonic Hall, Perth. Photograph by Yvonne Doherty. Courtesy of Guy Ben-Ary.

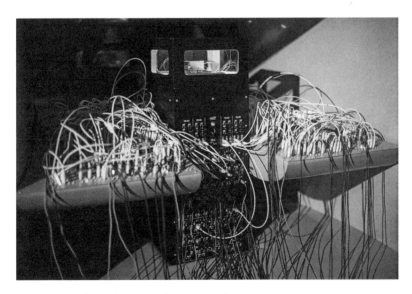

FIGURE 40. *cellF*: the incubator, neural interface, and synthesizers view, 2016. From the *Patient* exhibition, Cell Block Theatre, Sydney. Photograph by Alex Davis. Courtesy of Guy Ben-Ary.

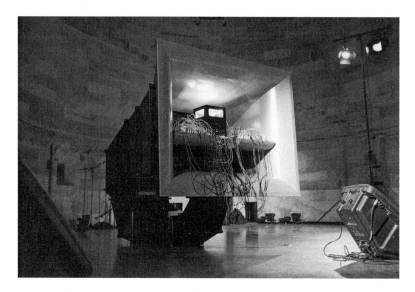

FIGURE 41. *cellF*, 2016. From the *Patient* exhibition,
Sydney. Photograph by Rafaela Pandolfini. Courtesy
of Guy Ben-Ary.

collaborations across micro to macro, living and nonliving forms—
from skin, neural, and embryonic stem cells to Ben-Ary and his host of
art, science, engineering, and musical collaborators, from their bodies
to ours, across biological lab, sterile hood, electrodes, neural interface,
synthesizer, and sculptural form. In fact, perhaps most significant in
such explorations with iPS technologies is the implication that our bio-
technological manipulations of both living and nonliving matter has
upended once again the forms and relations through which biological
entities develop with and against each other and, most powerfully, how
such entities cohere in and out of time. While IVF offers technologi-
cally assisted modes of reproduction that expand our kinship lines and
capacities for biological relatedness, now induced pluripotency further
relates a range of biological and abiological reformations, backward and
forward in time, without recourse to reproductive means and methods.

This seemingly endless plasticity of form, function, and temporal-
ity offers equally endless possibilities untethered from a dependency

on a reserve of human embryos. Yet reverse engineering embryonic stem cells gives rise to other dependencies, on transcription factors and their effects into the future, and on traces of past histories not completely erased. For Catherine Malabou, whose thinking on plasticity crosses both philosophy and neurobiology, a plastic form (of both matter and subjectivity) is capable of transformation as well as destruction, ever adept at differentiating without repetition and thus signaling the temporality of differential formation without recourse to reversion. She specifies: "Plastic, if you look in the dictionary, means the quality of a matter, which is at the same time fluid but also resisting. Once formed, it cannot go back to its previous state. For example, when the sculptor is working on the marble, the marble, once sculpted, cannot be brought back to its original state. So, plasticity is a very interesting concept because it means, at once, both openness to all kinds of influences, and resistance."[48] Although Malabou has been primarily concerned with connecting a philosophical history of subjectivity with a scientific understanding of the biological formation and reformation of our brains, if we bring this concept of plasticity alongside what we know about the formal and functional reversibility of iPS cells, we may continue to problematize the reinstantiation and suspension of pluripotency. Apart from the fact that the iPS cells are incredibly difficult to create, often with a low success rate, we do not know if iPS cells have the same potential as hES cells or what exactly their differences may be.[49] And while their cellular history is seemingly erased and rewritten, we cannot be sure how completely reprogrammed each iPS cell is, and so they cannot assuredly offer blank-slate, easily all-purpose, standardized malleability. As Hyun makes clear, recent studies have shown that iPS cells may retain an epigenetic memory of their cellular origins.[50] However, the same may be true for hES cells too, for human embryonic stem cells also have what Linda Hogle calls "layered sources of identity" because of their epigenetic history or because of particularized relationships to their culture medium, lab workers, and environments:

> Whether or not the cells are anthropomorphized by lab workers, there are other features that may well make a difference in

cell lines' behavior, namely, their individual human origins and unique genetic makeup. Each line is derived from the blastocysts of different donors, so the genetic identity is unique. Even if the cells only exist as such in culture, they could have epigenetic properties either because of their DNA fingerprint or to the interaction of that particular genetic makeup with the culture environment.[51]

Following Hogle, we can recognize a tension between standardizing stem cell lines and cultivating their differences, which may prove to be more effective in developing specific cell types or modeling specific diseases.[52] Needless to say, developmental pathways afforded by cellular plasticity, and instigated and maintained by researchers in variable cell-culture and lab situations, are convoluted with past and future forms, functions, and relations all traced within each other. Both hES and iPS cells' promises of pluripotency, then, are entangled with biological, social, and environmental histories, as well as imprecise future projections ongoing from the micro- to the macroscale, and inculcating a range of cellular matter, bodies, laboratory sites, technologies, research policies, and political climates.

POTENTIAL PROMISES

The promise of pluripotency is, of course, all about potentiality, but even more specifically than that, it is about whether or not we are able to turn back and reset time in order to offer an uncharted, unformed future potential in the face of conditional and unknown variables. But in perhaps the most controversial unfolding in the stem cell narrative to date—the arrival and subsequent dismissal of "stimulus-triggered acquisition of pluripotency" or STAP cells—we can begin to see how the enduring impulse to unravel pluripotency from many of its biological, social, and situational dependencies almost always proves to be an untenable pathway. On January 29, 2014, the highly reputable journal *Nature* posted online, and published the next day, an article and a letter detailing a novel approach in which pluripotency could be provoked by applying various stresses on somatic nonstem cells, again demon-

strating the influence of a cell's culturing environment but without the complications of nuclear transfer, genetic manipulation, or transcription factors. The primary author of both, Haruko Obokata, working at the Riken Center for Developmental Biology in Kobe, Japan, reported that she had converted adult mouse cells into pluripotent cells by exposing them to a low-pH, mildly acidic environment. With the help of senior researcher Teruhiko Wakayama, she tagged these newly pluripotent cells with a fluorescent protein and injected them into a mouse embryo; every tissue in the mouse began to glow green, meaning that the cells were indeed pluripotent. Initially using mouse T cells (a type of white blood cell), Obokata called the method "stimulus-triggered acquisition of pluripotency" and would go on to convert brain, skin, lung, liver, and other cell types. She claimed that the method was far more effective and much easier than the iPS method, with an average of 25 percent of cells surviving the stressors and 30 percent of those converting to a pluripotent state, in contrast with the approximately 1 percent success rate of iPS cells.[53]

Within a week, bloggers on the PubPeer website, a forum for the discussion of published scientific articles, noticed manipulations and duplications in the STAP cell images.[54] And stem cell researchers around the world, without being able to replicate the process even after Obokata subsequently published more details of the STAP protocols, began to question the validity of the method. Riken launched their own investigation, and at a press conference on March 14 in Tokyo, a committee noted that two of the duplicated images were, in fact, mistakes, while other issues, such as lengthy uncited passages lifted from another paper, were still under investigation. Teruhiko Wakayama had already announced a few days prior that he wanted both papers retracted, while the other senior author on the article, Charles Vacanti of Harvard University and Boston's Brigham and Women's Hospital, held to his position. But by the start of April, the Riken committee found Haruko Obokata guilty of scientific misconduct due to her falsification and manipulation of data. At the end of May, Obokata called for the retraction of one paper and, by early June, asked for the retraction the other, as finally too did Charles Vacanti.

At the conclusion of Riken's investigation, the committee believed that STAP cells were actually obtained by combining two different kinds of mouse cells, neither of which Obokata and her team reported to have used. Speaking about his investigative team's independent findings, Riken's Takaho Endo said he thought the mistakes were probably somewhat intentional, noting: "It is quite unlikely that this happens as a result of an accident or mistake."[55] On June 16, 2014, Teruhiko Wakayama then presented genetic data proving that Obokata had not used the mouse cells she claimed to have used, while another source suggested that the STAP cells were most likely conventional embryonic stem cells resulting from Obokata's switching of samples.[56] Finally, on July 2, Obokata and her collaborators formally retracted both papers from *Nature,* citing extensive errors.[57]

Meanwhile, Riken decided to allow Obokata to attempt to replicate and verify her results over the following five months while, in a separate statement, Charles Vacanti said he believed that further studies would uphold the validity of STAP.[58] Sadly on August 5, Yoshiki Sasai, Obokata's supervisor and coauthor on the papers as well as deputy director of Riken, died by suicide in the research facility.[59] Shortly following, Riken's Center for Developmental Biology was restructured and halved in size. By August 27, two Riken researchers, Shinichi Aizawa and Hitoshi Niwa, who were working separately from Obokata on their own replication tests with different types of cells and levels of stress, reported that after multiple attempts they were unable to produce STAP cells.[60] Although STAP seemed to have been dismissed at this point, in early September, Charles Vacanti published his own second revised protocol on his department's website, admitting "we made a significant mistake in our original declaration that the protocol was 'easy' to repeat," and this time, he suggested the addition of ATP (adenosine triphosphate, which transports energy for cell metabolism) to the low pH solution.[61] By December 2014, however, Haruko Obokata was herself unable to replicate STAP cells via her own protocols.[62] And by the end of the month, a separate investigative panel determined that STAP cells and their pluripotency were created through contamination by

embryonic stem cells; in fact, three distinct embryonic stem cell lines were found present in Obokata and her team's cell lines and tissue samples.[63]

While STAP remains unviable to date, the quickly hyped-up hope and failure of easily triggering pluripotency by stressing out any adult cell, without a reliance on sourced embryos, cloning modifications, or on genetic manipulation, lends focus to the fervor of potentiality embedded in the pluripotent promise—an intensely ever-expanding potentiality in which capaciousness is also traced with incapacity. Indeed, isolating and instrumentalizing pluripotency is simultaneously a promise and an incapacity to harness the unharnessable, whether in form, function, or temporality. In this fissure between the ever possible and the nearly impossible, between resistant and conditional plasticity and the material dependencies that hold things in place and time however temporally, between success and failure, this is where art practices may find openings to intervene, call attention, and problematize.

Speaking about her *Still Life with Stem Cells,* well before the advent of STAP or iPS, Patricia Piccinini was already telling us: "As with so much of this biotechnology, the extraordinary has already become the ordinary. The real question is 'what are we going to do with it.'"[64] As stem cell biotechnologies race ever onwards toward a seemingly obtainable and yet not fully isolatable ability to create any cell in any time, we are left with material formations and immaterial relations of dependency among those cells, cell cultures, bodies, and laboratories that unfold along sliding temporalities and varying scales, some predictable and even more unforeseen. We are also left with forms, narratives, promises, and failures that fall away, within and outside of living matter and time, and the unknowns that we think we have already charted and yet that remain unknown. Whether or not we know how to proceed, art practices that seek to unveil and activate these vital dependencies within promising biotechnological processes are themselves constantly reforming, revising, and recorrelating determinations of living and nonliving forms. These art practices are, in Piccinini's words again, "probably the wrong answer, but perhaps there

is something special in their incorrectness."[65] As wrong answers with unviable solutions or cures, such propositions tender an otherwise actuality of unpredictable future materialities housed within unerased histories and across newfound kinships. We would all do well to look at, sit with, make more of, and act alongside these special and in-correct, crucial yet conditional, formations of and outside life.

VITAL TIMES

Across this book, I have brought together a selection of art and architectural practices that form with life—synthesizing, maintaining, contextualizing, systematizing, and renewing biological matter beyond the precise functionality and temporal scope of the biotechnological methods employed and sometimes beyond the biological altogether. These are practices that take time, unveiling material exchanges and performing immaterial labors across temporalities that are fluid and nonteleological. From the generation to the regeneration of living forms, the artists and architects included in these chapters present ongoing and variable conditions for matter to develop, thrive, cohere, endure, and mutate, but without determinable goals in particular time frames and therefore always open to the possibility of disintegration and disavowal of life and the living.

Yet the quest to control and rehabilitate life quickly and efficiently, in targeted sites with predictable results, goes on. In February 2014, a group of Chinese scientists announced that they had edited the germline of monkeys using a new system called CRISPR/Cas9. Two twin female cynomolgus monkeys were successfully born with the resulting engineered genomes.[1] CRISPR (clustered regularly interspaced short palindromic repeat) and CRISPR-associated enzyme Cas9 work together to make precise, targeted genomic changes by adding, removing, or altering parts of the DNA sequence in a living cell. Used by certain bacteria to protect themselves from viruses invading their DNA,

143

the system works by way of a small piece of guide RNA (gRNA) that contains the targeted viral DNA sequence. This RNA binds to the exact DNA section, guiding the enzyme Cas9 to the precise location where it will splice out the virus. Beyond removing viral DNA, scientists recognized that they could engineer this system to cut and alter any genome, programming RNA to precisely target any DNA sequence and replacing the removed section with a new one.[2] Although other gene-editing technologies, like zinc-finger nuclease (ZFN) and transcription activator-like effector nuclease (TALENS), have previously been developed, CRISPR/Cas9 is by far much cheaper and faster.

By March and April 2015, both *Nature* and *Science* journals separately published articles attempting to establish ethical frameworks for the use of such precise genome-editing systems that specifically target a germline (the genetic material passed down through sperm and egg germ cells); both call for caution and more research into the risks of human germline editing.[3] Nonetheless, weeks later, a second Chinese team announced that they had edited the germline of a nonviable human zygote (a fertilized IVF egg cell qualified as nonviable because of its one oocyte nucleus and two sperm nuclei); the article emphasizes the future possibility of human therapeutic treatments and was published in the lesser-known journal *Protein & Cell* after it had been rejected by both *Science* and *Nature*.[4] While by no means celebrating the arrival of designer engineered babies as the worldwide media would spin it, the team also called for further research since the efficiency of their germline editing was low, not every cell was completely edited, and a number of other mutations were detected outside of the targeted sequence—all perhaps reasons contributing to the article's initial rejection by the other two top journals. By August 2, 2017, researchers in Oregon, California, China, and South Korea announced in *Nature* that they had successfully used CRISPR to edit out a precise gene mutation in human embryos that would cause a certain heart condition, this time producing embryos in which all cells were completely free of the target mutation while avoiding other unwanted mutations.[5] Then in November 2018, a researcher at the Southern University of Science and Technology of China, He Jiankui,

announced that he had used CRISPR to edit the genomes of two embryos in order to disable the genetic pathway used by HIV to infect cells. He subsequently implanted the embryos into a woman who recently gave birth to twin girls, each with varying degrees of the modifications.[6] Jiankui seemingly worked under a veil of secrecy, has not published his procedure and protocols anywhere, and his claims have, as yet, not been independently verified.[7]

The combined quickness and precision promised by CRISPR can be contrasted with the durational, performative, and relational events occurring in the art and architectural installations within this book—projects that instead take time, that ask us to spend time with things and beings that are imprecise, that compel us to give into accidents, failures, and speculations. While I am certainly by no means discounting the experimental nature of biological explorations with their own imprecisions, accidents, and failures, this book is an effort to call attention to other parallel practices outside of the sciences that stay with, for lack of a better word, the messiness of life. The book's trajectory of works showcases an awareness of material dependencies that propose, without necessarily prescribing, how we could redefine and potentially recoalesce the matter around, inside, and beyond our biological selves and, at times, beyond biology altogether. To that end, each of the projects in this book initiates various encounters across the intracellular to the extracellular and onward to the ecosystemic with a number of interactions arising across and between. These ongoing material exchanges are framed through relations of uneven dependency and across time those dependencies become vital—in terms of both vital necessity as well as vitalism's persistent generative impulse—to the synthesis and renewal of life oftentimes at the threshold of and dependent upon nonlife. Spending time and staying with these ambiguous forms of life at the limits of the living allows us to see how each act of formation is determined and held up by some other material object and occurrence. As we witness these vital dependencies unfolding, my hope is that beyond the scope of this book we may also begin to see how other dependencies are at work within larger sociopolitical determinations of who and what qualifies as modifiable and renewable

life—determinations that are poised for revision in the face of ever-constant human manipulation, for and by some and not others.

While this book has been aiming to make a case for the inclusion of art and architectural practices in our changing formulations of life, such practices are by no means making any definitive claims on how we should respond ethically or politically with full acknowledgment of the contingent ways in which life is expanding beyond itself in both form and time. After spending my own time with these biological, technological, and artistic practices, both in and out of labs and galleries, and as my own initial fears of not understanding the science turned into unease and concern for the very pointed trajectories we currently have devised for living forms and matter, I have come to believe that it can be enough that particular art and architectural works make visible the ways in which we now aim to reform and resituate certain kinds of life efficiently toward specifically predictable outcomes. It can be enough that artists and architects are offering us expanded durations of time to sit with and within processes through which living matter is transformed, to perform and interact in our own living human bodies, many times quite uncomfortably, with the resulting forms and situations while at times re-envisioning alternative constructions and emplacements. And, indeed, each of the projects on which I chose to focus does this very kind of work: whether framing the generation of living matter within a longer temporal attention span, activating material infrastructures alongside immaterial processes of care, engaging with the force and impact of situational contexts, considering necessary evolutionary symbioses between living and nonliving matter, or, finally, addressing regeneration outside of living and dying time.

However, it is also never enough, as we have learned from so many forms and times of activist art, and so beyond the walls of the gallery we may also need to instigate other kinds of collaborations alongside the art/science ones offered by these projects—across public policy, economics, or legal studies, for instance—in effect to more overtly acknowledge our specific ethical and political dependencies. This would shift emphases from the kinds of critical work each project is doing

toward the possible work any one of us could do in engaging with such projects, beyond either celebrating or questioning their modes of critique and beyond labs and galleries altogether. Without a doubt, any potential impact and consequence of a participant's response, from affect to action, upon spending time with one of these art or architectural proposals could be contextualized within ongoing conversations surrounding current reformulations and re-enforcements of biopower, continued recirculations of biocapital across varied and expanding global bioeconomies, or the intense demands on a bioethics to frame who gets to do what to whom. Or we might recontextualize any potential material action that occurs through the forms and times of these projects as de-emphasizing the biopolitical frame altogether, as you will remember Elizabeth Povinelli entreats us to consider, instead moving toward a longer and wider reckoning with geontopower in which life is but one state of assemblage among many.[8]

For their own part, we can expect that artists and architects will start turning to CRISPR, and whatever comes after and next to CRISPR, to think longer and wider about our quick and precise ability to revise living matter. Indeed, as I write this epilogue, the exhibition *Future Emerging Art and Technology* at the LifeSpace Science Art Research Gallery in Dundee, Scotland, has closed.[9] It included a new work developed by the artist Anna Dumitriu, who used CRISPR/Cas9 to edit the germline of *E. coli,* rendering the bacteria back to its preantibiotic and thus preantibiotic-resistant state by splicing out an ampicillin-resistant gene, where ampicillin is a form of penicillin we now are regularly overprescribed (Figure 42). Stitching up and embroidering over the holes in a woman's WWII-era skirt suit with silk that was dyed with the CRISPR-modified bacteria, *Make Do and Mend* commemorates the first time penicillin was given to humans, in 1941 (Figure 43).[10] While the work seeks to start a conversation about the current rise in antibiotic-resistant infections, the use of CRISPR to produce bacteria in a state that only existed before the appearance of antibiotics gives us pause to acknowledge the long-term impact of human-directed and targeted biotechnologies that over time catalyze indeterminable outcomes beyond human control, foreshadowing future outlays of CRISPR as well.

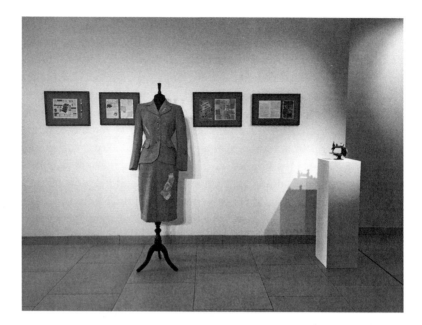

FIGURE 42. *Make Do and Mend*, Anna Dumitriu in collaboration with Sarah Goldberg and Roee Amit at the Synthetic Biology Laboratory for the Decipherment of Genetic Codes at Technion, Haifa, as part of the EU FET Open Project MRG-Grammar, 2016–17. Supported by FEAT. FEAT is funded by the EU-backed program FET (Future and Emerging Technologies) Open and has received funding from the European Union's Horizon 2020 research and innovation program under grant agreement 686527 (H2020–FETOPEN–2015–CSA), with further assistance by Heather Maclyne (University of Sussex) and Rob Neely (University of Birmingham). Courtesy of Anna Dumitriu.

As CRISPR becomes capable of rectifying the unforeseen issues created by earlier biotechnologies, Dumitriu's work asks: Won't it just introduce more problems to come—ones that we cannot even begin to imagine now?[11]

Developed before CRISPR, zinc-finger nucleases (ZFNs) is a less fast, more costly gene-editing system. Another artist, Adam Zaretsky, has used ZFNs to "frack" the whole genome of *Arabidopsis thaliana* plants (a kind of mustard weed) in his 2012 work *Bipolar Flowers* (Figure 44). With epigenetic regulators vying for the same binding domain or genomic landing point, never-before-seen forms of growth are

FIGURE 43. *Make Do and Mend*, detail, 2016–17.
Courtesy of Anna Dumitriu.

produced "without a care for repeatability or utilizability," as Zaretsky notes, and perhaps not even qualifying as a plant anymore.[12] More recently, beginning in 2016, Zaretsky has experimented with altering the human genome via other techniques of electroporation, biolistics, and microinjection in a triptych of labs he calls *Methods of Transgenesis: Shoot, Shock, and Inject,* alternately using a machine that opens membranes with a high voltage pulse (an electroporator), a gene gun that mixes DNA with particles of heavy metal to be shot into cells, and, finally, a thin glass micropipette capable of puncturing cell membranes and injecting foreign material into their nuclei.[13] Such deliber-

FIGURE 44. *Bipolar Flowers,* Adam Zaretsky, 2012. Photograph by David Louwrier. Courtesy of Adam Zaretsky.

ate actions force us to consider what happens over the long haul when human-engineered organisms and species leave the contained space of the lab, entering already existing ecosystems and cohabitating within our bodies and alongside other species. Zaretsky has since ordered a Do-It-Yourself CRISPR set offered and crowd-sourced on Indiegogo.[14]

As we are capable of forming and altering life more easily, quickly, and efficiently, we are also given the opportunity to re-enact and revise those processes in different contexts over more extensive periods of time, bringing forth with more urgency the unforeseen material encounters that are out of our hands and often outside the domain of the living. Art and architecture that attend to processes, performances, and relations of objects, structures, and bodies have already been invested in sustaining and relinquishing, dispersing and reintegrating matter with matter across time; in turning toward the biological, artists and architects have the ability to instigate current and future formulations of life, whether hybridized, destabilized, at the threshold, or reintegrated with nonlife. But the question remains: What should we do with these propositions? As the instrumentalization of life continues into the twenty-first century, let us take time with events and practices of forming life that counter control with indeterminacy, clarity with ambiguity, security with vulnerability. Within this messiness are vital dependencies that we might recognize as ongoing sites of contestation through which life endures but also, perhaps most significantly, transforms and diversifies beyond itself.

ACKNOWLEDGMENTS

Years ago, on the last day before summer break, I was looking for a spectacular send-off for my contemporary art history class, and biological art seemed to be just the thing. As I pieced together that very first lecture, I knew there was so much more beyond the spectacle and so the idea for a book began to take shape. I want to thank those first students as well as the ones who followed across the years, especially my research assistant, Aisha Motlani, who joined me at the very start of this project. I am immensely grateful to my art history department at the University of Wisconsin–Milwaukee for fostering such an open and reassuring atmosphere that allowed me to embark on this research and leave my office for laboratories and galleries around the world. It is a huge pleasure to call Derek Counts, Tanya Tiffany, Ying Wang, Richard Leson, Kay Wells, Sarah Schaefer, David Pacifico, Michael Aschenbrenner, Jocelyn Boor, and Leigh Mahlik my colleagues, as well as Linda Brazeau and the late Jeffrey Hayes and Andrea Stone, whose care and support in those early years cannot be forgotten. Now in London, Elena Gorfinkel is and always will be my intellectual co-conspirator; she listened to me work out both the foundational concepts and the small details of this book with passion and patience, and our ongoing conversations around these ideas and everything beyond will always continue to deeply affect my thinking.

I am thankful to have spent 2013–14 as a fellow at the Center for 21st Century Studies (UW–Milwaukee) with early drafts of these

ACKNOWLEDGMENTS

chapters, under the wise direction of Richard Grusin and surrounded by the encouragement of other fellows—Marcus Filippello, Elena Gorfinkel, Dehlia Hannah, Tracey Heatherington, Jenny Kehl, Annie McClanahan, Michael Oldani, and Arijit Sen (my dear and steadfast guide into all things architecture). In addition, I am grateful to my inspiring friends and colleagues Aneesh Aneesh, Erica Bornstein, Carolyn Eichner, Kennan Ferguson, Jennifer Jordan, Yevgeniya Kaganovich, Jim Charles, Meredith Hoy, and Ann Mattis; their words and acts of kindness have made these past few years rewarding and the difficulties bearable.

This book is truly indebted to the artists and architects I have been lucky enough to spend time with in person as well as converse with over email. Oron Catts and Ionat Zurr graciously welcomed me twice to SymbioticA, the creative hub for all things art and science at the other end of the world in Perth, Australia, and Chris Cobilis made the arrangements; I could not have embarked on any of this research were it not for their engagement with my thinking and, of course, their groundbreaking work. While at SymbioticA, I met Guy Ben-Ary and am grateful to him for spending time speaking with me about his past and future projects. I'm also pleased that Biofilia at Aalto University in Helsinki included me in its biotech for artists workshop; while there, I could not have asked for better (or more fun) lab partners in Marietta Radomska and David Benqué. Along with Oron, Ionat, Guy, and David, big thanks go to Tobias Revell, Superflux, Alexandra Daisy Ginsberg, Jenny Sabin, Rachel Armstrong, Philip Beesley, Patricia Piccinini, Anna Dumitriu, and Adam Zaretsky for generously providing me with images of their work.

With a manuscript finally in tow, I am extraordinarily grateful for the ongoing support of my editor, Pieter Martin, with whom I've worked on two books now. Pieter truly believed in this project from the start and ushered it through to completion. The reviews from my two readers provided necessary and incisive suggestions for revision, and I hope this book is stronger because of their astute candor.

Finally, the roots of my understanding of vitality, dependency, and the forming of life are entangled with those for whom a simple "thank

you" will never be enough. My love and deep gratitude go to my parents, John and Loretta Johung, for their endless support and belief in me; Lydia Chung and Paul, Cynthia, and David Chung, who are always with me; Kimberly Johung, Francis Chan, and Aiden, Colson, and Ava, all reminders of what is really important; and Tessa Johung, who, while a medical student, talked with me about stem cells and sent me articles about CRISPR, while having to decode everything for me. I have no idea how I would have understood any of it without her help. As I revised (with a newborn), Mia LeTendre gave me precious and necessary time to myself and with my work. Finally, Andy Noble has always been a true partner, engaging with these thoughts from the very beginning while expanding my life and love in all ways. And then Arthur came into our world right alongside the writing of this book and changed my thinking and world immeasurably. All of this, and of course so much more, is for him (and for our new little one, who will be making his debut as this book goes to print).

NOTES

INTRODUCTION

1. Hannah Landecker, "Living Differently in Time: Plasticity, Temporality, and Cellular Biotechnologies," in *Technologized Images, Technologized Bodies,* ed. Jeanette Edwards, Penny Harvey, and Peter Wade (New York: Berghahn Books, 2010), 213–14.

2. Architectural historian Vincent Scully, for example, links formal attributes of ancient Greek temples to the changing experiences of moving through the whole architectonic complex, inclusive of both structure and site. By focusing attention on the mutually constitutive relationship between a formal structure and its variable use, Scully activates the static building, conceiving of it instead as an embodied, living form that depends on human dwellers and users and their desires, motivations, and demands. These participants act as mediators who continually reconstruct the links between the site and structure while also revising their understanding of their spatial situation within the larger world. Vincent Scully, *The Earth, the Temple, the Gods: Greek Sacred Architecture* (New Haven, Conn.: Yale University Press, 1979).

3. David Leatherbarrow, "Architecture's Unscripted Performance," in *Performative Architecture: Beyond Instrumentality,* ed. Branko Kolarevic and Ali M. Malkawi (New York: Spon Press, 2005), 7.

4. Greg Lynn, *Animate Form* (Princeton, N.J.: Princeton Architectural Press, 1999).

5. Kas Oosterhuis, *Hyperbodies: Towards an E-motive Architecture* (Basel, Switzerland: Birkhäuser, 2003).

6. Alberto T. Estévez, "Genetic Barcelona Project: The Genetic Creation of Bioluminescent Plants for Urban and Domestic Use," *Leonardo* 4 (February 2007); and "Genetic Barcelona Project," in *Bio-design,* ed. William Myers (New York: MOMA, 2012).

7. Marcos Cruz and Steve Pike, "Introduction: Neoplasmatic Design: Design Experimentation with Bio-architectural Composites," in "Neoplasmatic Design," ed. Marcos Cruz and Steve Pike, special issue, *Architectural Design* 78, no. 6 (2008): 12.

8. Stephen Kellert identifies this "inherent human affinity" with the natural world as "biophilic." See Stephen R. Kellert, "Dimensions, Elements, and Attributes of Biophilic Design," in *Biophilic Design,* ed. Stephen R. Kellert, Judith H. Heerwagen, and Martin L. Mador (Hoboken, N.J.: John Wiley and Sons, 2008), 3.

9. William Myers, "Beyond Biomimicry," in *Bio-design*, ed. William Myers (New York: MOMA, 2012), 17.

10. Ginger Krieg Dosier, "BioBrick," in *Bio-design*, ed. William Myers (New York: MOMA, 2012), 78–79.

11. Henk Jonkers, "Bioconcrete," in *Bio-design*, ed. William Myers (New York: MOMA, 2012), 80–81.

12. Mitchell Joachim, "Fab Tree Hab," in *Bio-design*, ed. William Myers (New York: MOMA, 2012), 58.

13. "A Conversation with Author Janine Benyus," Biomimicry 3.8, https://biomimicry.net/the-buzz/resources/conversation-author-janine-benyus/.

14. Nikolas Rose, *The Politics of Life Itself* (Princeton, N.J.: Princeton University Press, 2007), 3.

15. Rose, *Politics of Life Itself*, chap. 1. See also Kaushik Sunder Rajan, *Biocapital: The Constitution of Postgenomic Life* (Durham, N.C.: Duke University Press, 2007).

16. Catherine Waldby, *The Visible Human Project: Informatic Bodies and Posthuman Medicine* (New York: Routledge, 2000). See also Catherine Waldby and Robert Mitchell, *Tissue Economies: Gifts, Commodities, and Bio-value in Late Capitalism* (Durham, N.C.: Duke University Press, 2006).

17. Michel Foucault, *Society Must Be Defended*, trans. David Macey (New York: Picador, 2003), 241.

18. Michael Hardt and Antonio Negri, *Empire* (Cambridge, Mass.: Harvard University Press, 2001).

19. Giorgio Agamben, *Homo Sacer*, trans. Daniel Heller-Roazen (Stanford, Calif.: Stanford University Press, 1998).

20. Agamben, *Homo Sacer*.

21. Sarah Franklin, "Life Itself: Global Nature and the Genetic Imaginary," in *Global Nature, Global Culture*, ed. Sarah Franklin and Celia Lury (London: Sage, 2000), 191.

22. Evelyn Fox Keller, *The Century of the Gene* (Cambridge, Mass.: Harvard University Press, 2000), 8. See also Evelyn Fox Keller, "Century beyond the Gene," *Journal of Biosciences* 30 (2005): 3–10. For a detailed overview of the history behind the genocentric focus of contemporary biology as well as its ultimate dismantling, see Lenny Moss, *What Genes Can't Do* (Cambridge, Mass.: MIT Press, 2004).

23. Samantha Frost, *Biocultural Creatures: Towards a New Theory of the Human* (Durham, N.C.: Duke University Press, 2016), 98–99. See also Donna Haraway, *Modest_Witness@Second_Millenium.FemaleMan©_Meets_OncoMouse*™ (New York: Routledge, 1997); and Richard Lewontin, *The Triple Helix: Gene, Organism, and Environment* (Cambridge, Mass.: Harvard University Press, 2002).

24. Catherine Malabou, "One Life Only: Biological Resistance, Political Resistance," *Critical Inquiry*, http://criticalinquiry.uchicago.edu/one_life_only/ (accessed September 27, 2016).

25. Alex Reis, Breton Hornblower, Brett Robb, and George Tzertzinis, "CRISPR/Cas9 and Targeted Genome Editing: A New Era in Molecular Biology," *New England Biolabs* (2014): https://www.neb.com/tools-and-resources/feature-articles/crispr-cas9-and-targeted-genome-editing-a-new-era-in-molecular-biology?device=pdf (accessed September 27, 2016).

26. Henri Bergson, *Creative Evolution*, trans. Arthur Mitchell (New York: Dover, 1998), 13.

27. Bergson, *Creative Evolution*, 76, 132.

28. Bergson, 39.

29. Gilles Deleuze, *Bergsonism*, trans. Hugh Tomlinson and Barbara Habberjam (New York: Zone Books, 1991).

30. Deleuze, *Bergsonism*, 104.

31. Hans Driesch, *The History and Theory of Vitalism*, trans. C. K. Ogden (London: Macmillan, 1914), 204.

32. Jane Bennett, *Vibrant Matter: A Political Ecology of Things* (Durham, N.C.: Duke University Press, 2010), 80.

33. Diana Coole and Samatha Frost, "Introducing the New Materialism," in *New Materialisms: Ontology, Agency, and Politics,* ed. Diana Coole and Samantha Frost (Durham, N.C.: Duke University Press, 2010), 10.

34. Rosi Braidotti, *The Posthuman* (Cambridge: Polity, 2013), 60.

35. Jane Bennett, *Vibrant Matter: A Political Ecology of Things* (Durham, N.C.: Duke University Press, 2010), x.

36. See Baruch Spinoza, *Ethics: Treatise on the Emendation of the Intellect, and Selected Letters,* trans. Samuel Shirley, ed. Seymour Feldman (Indianapolis: Hackett, 1992).

37. Georges Canguilhem, *A Vital Rationalist* (New York: Zone Books, 1994), 288.

38. Monica Greco, "On the Vitality of Vitalism," *Theory, Culture & Society* 22, no. 1 (February 2005): 17.

39. Karen Barad, "Matter Feels, Converses, Suffers, Desires, Yearns, and Remembers: Interview with Karen Barad," in *New Materialisms: Interviews and Cartographies,* ed. Rich Dolphijn and Iris van der Tuin (Ann Arbor, Mich.: Open Humanities Press, 2012), 61.

40. Barad, "Matter Feels," 69. See also Karen Barad, *Meeting the Universe Halfway: Quantum Physics and the Entanglement of Matter and Meaning* (Durham, N.C.: Duke University Press, 2007).

41. Barad, "Matter Feels," 68.

1. VITAL SYNTHESIS

1. "Yours Synthetically: Call for Artworks, Exhibits and Projects," posted by Bruce Sterling on Wired, April 2, 2013, https://www.wired.com/2013/04/yours-synthetically-call-for-artworks-exhibits-and-projects/ (accessed January 10, 2019).

2. Francis Crick, "On Protein Synthesis," *Symposia of the Society for Experimental Biology* 12 (1958): 138–63; and "Central Dogma of Molecular Biology," *Nature* 227 (1970): 561–63.

3. Martin Hieslmair interview with Matthew Gardiner, "We Shape Our World," *Ars Electronica* (blog), June 6, 2013, http://www.aec.at/aeblog/en/2013/06/06/wir-formen-unsere-welt (accessed June 6, 2013).

4. Geoff Baldwin, Travis Bayer, Robert Dickinson, Tom Ellis, Paul S. Freemont, Richard I. Kitney, Karen Polizzi, and Guy-Art Stan, *Synthetic Biology: A Primer* (London: Imperial College Press, 2012), 19.

5. Sophia Roosth, *Synthetic: How Life Got Made* (Chicago: University of Chicago Press, 2015), 4–5.

6. "The Synthetic Kingdom: A Natural History of the Synthetic Future," Alexandra Daisy Ginsberg, http://www.daisyginsberg.com/projects/synthetickingdom.html (accessed June 6, 2013).

7. Alexandra Daisy Ginsberg, "Design as Machines Come to Life," in *Synthetic Aesthetics*, ed. Alexandra Daisy Ginsberg, Jane Calvert, Pablo Schyfter, Alistair Elfick, and Drew Endy (Cambridge, Mass.: MIT Press, 2014), 56.

8. Sophia Roosth, *Synthetic: How Life Got Made* (Chicago: University of Chicago Press, 2015), 24.

9. Roosth, *Synthetic*, 39–43.

10. Oron Catts and Ionat Zurr, "Countering the Engineering Mindset: The Conflict of Art and Synthetic Biology," *Synthetic Aesthetics*, ed. Alexandra Daisy Ginsberg, Jane Calvert, Pablo Schyfter, Alistair Elfick, and Drew Endy (Cambridge, Mass.: MIT Press, 2014), 28.

11. Tobias Revell, "Into Your Hands Are They Delivered," Studiolab, http://studiolab.di.rca.ac.uk/projects/into-your-hands-are-they-delivered (October 1, 2013).

12. Revell, "Into Your Hands."

13. Eduardo Kac, *Genesis* (1998/199), http://www.ekac.org/geninfo.html.

14. Superflux, "Evidence File," Dynamic Genetics versus Mann, http://www.dynamicgenetics.co.uk/?/evidence-file/ (accessed October 1, 2013).

15. Christina Agapakis, "DNA Stories," *Superflux* (blog), http://www.superflux.in/blog/dnastories (accessed October 1, 2013).

16. "New Weatherman Manifesto," David Benqué (website), http://www.davidbenque.com/files/New-Weathermen-Manifesto.pdf (accessed October 1, 2013).

17. John Thackara, "Republic of Salivation (Michael Burton and Michiko Nitta)," *Design and Violence*, MOMA, http://designandviolence.moma.org/republic-of-salivation-michael-burton-and-michiko-nitta/ (accessed December 1, 2013).

18. Christina Cogdell, "From BioArt to BioDesign," *American Art* 25, no. 2 (2011): 28.

19. David Benqué, "Blueprints for the Unknown: Questioning the 'Design' of Life," in *Meta-life: Biotechnologies, Synthetic Biology, and the Arts*, ed. Annick Bureaud, Roger F. Malina, and Louise Whitely (Cambridge, Mass.: Leonardo/MIT Press, 2014), Kindle.

20. Anthony Dunne and Fiona Raby, *Speculative Everything: Design, Fiction, Social Dreaming* (Cambridge, Mass.: MIT Press, 2014), 189.

21. uncertain commons, *Speculate This!* (Durham, N.C.: Duke University Press, 2013), chap. 1, iBook.

22. uncertain commons, *Speculate This!*, chap. 1.

23. uncertain commons, chap. 1.

24. Synthetic Biology Engineering Research Center, "Bootstrapping Biotechnology: Engineers Cooperate to Realize Precision Grammar for Programming Cells," ScienceDaily, https://www.sciencedaily.com/releases/2013/03/130314111851.htm (accessed January 10, 2019).

25. Drew Endy, personal interview, July 2013.

26. Drew Endy and Alistair Elfick, "Synthetic Biology: What It Is and Why It Matters," in *Synthetic Aesthetics*, ed. Alexandra Daisy Ginsberg, Jane Calvert, Pablo Schyfter, Alistair Elfick, and Drew Endy (Cambridge, Mass.: MIT Press, 2014), 16.

27. Endy calls for other researchers to "expand upon the genetic grammar initiated here, to incorporate additional genetic functions and to translate the common rule set beyond E.coli." Drew Endy, quoted in Synthetic Biology Engineering Research Center, "Bootstrapping Biotechnology."

28. J. L. Austin, *How to Do Things with Words* (Cambridge, Mass.: Harvard University Press, 1975), 18.

29. Austin, *How to Do Things with Words*, 14–15.

30. Peggy Phelan, *Unmarked: The Politics of Performance* (London: Routledge, 1993), 150.

31. Phelan, *Unmarked*, 150.

32. Phelan, 150.

33. For a multitude of examples, see William Myers, *Bio Design: Nature, Science, Creativity* (New York: MOMA, 2012).

2. VITAL MAINTENANCE

1. For a more detailed description of these dolls, see Oron Catts and Ionat Zurr, "Growing Semi-living Sculptures: The Tissue Culture and Art Project," *Leonardo* 45, no. 4 (2002): 366–68.

2. For a list of audience worries, see http://tcaproject.org/worry_machine/list ?page=3.

3. For more about tissue engineering technology, see Catts and Zurr, "Growing Semi-living Sculptures," 365.

4. Oron Catts and Ionat Zurr, "Are the Semi-living Semi-good or Semi-evil?," *Technoetic Arts* 1, no. 1 (2003): 53.

5. For Adele Senior, "the *performance* of the rituals in TC&A's installations arguably exposes them as just that—rituals which gain their authority though the process of (re)iteration." Adele Senior, "Towards a (Semi-)Discourse of the Semi-living: The Undecidability of a Life Exposed to Death," *Technoetic Arts* 5, no. 2 (2007): 109.

6. Email interview with Oron Catts, July 3, 2013.

7. See the video of the funeral service at Science Gallery Dublin, "Visceral: The Funeral," YouTube video, 4:10, March 8, 2011, http://www.youtube.com/watch?v =1VLhnVwNpfo (accessed August 6, 2013).

8. David Benque, http://www.davidbenque.com/ (accessed August 6, 2013).

9. Email interview with Oron Catts, July 3, 2013.

10. Kelly Rafferty, "Regeneration: Tissue Engineering, Maintenance, and the Time of Performance," *TDR: The Drama Review* 56, no. 3 (Fall 2012): 88.

11. See website for these and more worries, TC&A Project, http://tcaproject.org/worry _machine/list?page=3 (accessed July 3, 2013).

12. Oron Catts and Ionat Zurr, "The Tissue Culture and Art Project: The Semi-living as Agents of Irony," in *Performance and Technology: Practices of Virtual Embodiment and Interactivity*, ed. Susan Broadhurst and Josephine Machon (New York: Palgrave, 2006), 159. Also cited in Rafferty, "Regeneration," 89. For more about the *Pig Wings* project, see TC&A Project, http://lab.anhb.uwa.edu.au/tca/pig-wings/ (accessed January 25, 2019).

13. Catts and Zurr, "Are the Semi-living Semi-good or Semi-evil?," 55.

14. "SymbioticA: Symposia and Conferences," University of Western Australia (website), http://www.symbiotica.uwa.edu.au/activities/symposiums.

15. For a survey of the concept of care, see Warren T. Reich, "History of the Notion of Care," *Encyclopedia of Bioethics,* rev. ed., ed. Warren T. Reich, 319–31 (New York: Simon & Schuster Macmillan, 1995), http://care.georgetown.edu/Classic%20Article .html (accessed December 2012).

16. Martin Heidegger, *Being and Time,* trans. John Macquarrie and Edward Robinson (New York: Harper Perennial, 2008), 242.

17. Heidegger, *Being and Time.*

18. John Haugeland, "Reading Brandom Reading Heidegger," *European Journal of Philosophy* 13, no. 3 (2005): 421–28. See also Robert Brandom, *Tales of the Mighty Dead* (Cambridge, Mass.: Harvard University Press, 2002), and Stephen Mulhall, *Routledge Philosophy Guidebook to Heidegger and 'Being and Time'* (London: Routledge, 2005), among others.

19. Heidegger, *Being and Time,* 243.

20. Heidegger, 243.

21. Mulhall, *Routledge Philosophy Guidebook to Heidegger,* 113–14.

22. Martin Heidegger, "Letter on Humanism," *Basic Writings,* ed. David Farrell Krell, 213–65 (New York: HarperCollins, 1993).

23. Timothy Campbell, *Improper Life: Technology and Biopolitics from Heidegger to Agamben* (Minneapolis: University of Minnesota Press, 2011), 27.

24. Rafferty, "Regeneration," 90.

25. For Rafferty's analysis of Ukeles, Kelly, and Saar, see Rafferty, "Regeneration," 90–94.

26. Mierle Laderman Ukeles, "Manifesto for Maintenance Art," 1969, https://www .queensmuseum.org/wp-content/uploads/2016/04/Ukeles_MANIFESTO.pdf (accessed January 11, 2019).

27. Shannon Jackson, *Social Works: Performing Art, Supporting Publics* (London: Routledge, 2011), 87.

28. See Lucy Lippard, *Six Years: The Dematerialization of the Art Object from 1966 to 1972* (Berkeley: University of California Press, 1997).

29. Jackson, *Social Works,* 88.

30. Jackson, 93.

31. See Kaushik Sunder Rajan, *Biocapital: The Constitution of Postgenomic Life* (Durham, N.C.: Duke University Press, 2006).

32. Melinda Cooper, *Life as Surplus: Biotechnology and Capitalism in the Neoliberal Era* (Seattle: University of Washington Press, 2008), 4.

33. See Catherine Waldby and Robert Mitchell, eds., *Tissue Economies: Blood, Organs, and Cell Lines in Late Capitalism* (Durham, N.C.: Duke University Press, 2006). Also see Rajan, *Biocapital,* and Cooper, *Life as Surplus.*

34. See Oron Catts and Ionat Zurr, eds., *Partial Life* (Open Humanities Press, e-book), http://www.livingbooksaboutlife.org/books/Partial_Life (accessed July 3, 2013).

35. See http://tcaproject.org/projects/noark/neolifism.

36. Hannah Landecker, "Living Differently in Time: Plasticity, Temporality, and Cellular Biotechnologies," in *Technologized Images, Technologized Bodies,* ed. Jeanette Edwards, Penny Harvey, and Peter Wade (New York: Berghahn Books, 2010), 219.

37. Hannah Landecker, *Culturing Life: How Cells Became Technologies* (Cambridge, Mass.: Harvard University Press, 2007), 13.

38. Catts and Zurr, "Growing Semi-living Sculptures," 367.

39. Catts and Zurr, 367.

40. Catts and Zurr, 367.

41. Email interview with Oron Catts, July 3, 2013.

42. John Schwartz, "Museum Kills Live Exhibit," *New York Times,* May 13, 2008, http://www.nytimes.com/2008/05/13/science/13coat.html.

43. Email interview with Oron Catts, July 3, 2013.

44. *Anatomy,* season 3, episode 2, "Tissue," directed by Alethea Jones (Matchbox Pictures, 2012), DVD.

45. Oron Catts and Ionat Zurr, *Crude Life: The Tissue Culture and Art Project,* exhibition catalog, Centrum Sztuki Współczesnej Laznia/Laznia Centre for Contemporary Art, Gdańsk, Poland, March 20–April 22, 2012, 145.

46. See Monika Bakke's description of walking around the series of objects: "The viewer starting her walk from the title and continuing around the display will move in a clockwise direction (like the right-hand side spiral or the double helix of DNA of life as we know it), repeating the movement supposedly performed by Rabi Loew (also known as Maharal) in the ritual of bring the Golem to life. Walking the other way around, as the legend has it, resulted in the opposite effect on the Golem, and was eventually used to terminate his life." Quoted in Catts and Zurr, *Crude Life,* 55.

47. Nicolas Perpitch, "Art and Science Blurred in Exploration of Human Relationships with Other Life Forms," *ABC News* (Australian Broadcasting Corporation), October 24, 2016, http://www.abc.net.au/news/2016–10–25/art-and-science-project-explores-relationship-between-people-an/7963574 (accessed October 25, 2016).

3. VITAL CONTEXTS

1. Jenny Sabin and Peter Lloyd Jones, "Nonlinear Systems Biology and Design: Surface Design," in *ACADIA 08: Silicon + Skin, Biological Processes and Computation,* ed. Andrew Kudless (Association for Computer-Aided Design in Architecture, 2008), 1, http://labstudio.org/Papers/Sabin_Jones_ACADIA08.pdf.

2. See Christian Frantz, Kathleen M. Stewart, and Valerie M. Weaver, "The Extracellular Matrix at a Glance," *Journal of Cell Science* 123 (2010): 4195–200.

3. Frantz, Stewart, and Weaver, "Extracellular Matrix at a Glance," 4197.

4. Frantz, Stewart, and Weaver, 4198.

5. Henry Fountain, "Human Muscle, Regrown on Animal Scaffolding," *New York Times,* September 16, 2012, http://www.nytimes.com/2012/09/17/health/research/human-muscle-regenerated-with-animal-help.html?pagewanted=2&_r=0 (accessed September 16, 2012).

6. Kim E. M. Benders, P. René van Weeren, Stephen F. Badylak, Daniel B. F. Saris, Wouter J. A. Dhert, and Jos Malda, "Extracellular Matrix Scaffolds for Cartilage and Bone Regeneration," *Trends in Biotechnology* 31, no. 3 (March 2013): 169–76.

7. "The functional outcome of ECM-derived scaffolds depends on several factors, including retention of growth factors within the ECM, its surface topology, modulation of the immune response, and the microenvironmental cues exerted on the cells, such as biomechanical loading." Benders et al., "Extracellular Matrix Scaffolds."

8. Jenny Sabin and Peter Lloyd Jones, "Sabin+Jones LabStudio: Nonlinear Systems Biology and Design," *American Institute of Architects Report on University Research* 5, no. 6, https://www.brikbase.org/sites/default/files/aiab092723.pdf (accessed January 10, 2019).

9. Sabin+Jones LabStudio, "Ground Substance," http://jennysabin.com/?p=89 (accessed April 1, 2013).

10. Jenny Sabin and Peter Lloyd Jones, "Design Research in Practice: A New Model," in *LabStudio: Design Research Between Architecture and Biology* (London: Routledge, 2018), 37–38.

11. Trey Popp, "An Architect Walks into the Lab," *Pennsylvania Gazette*, January/February 2009, 32.

12. Sabin and Jones, "Sabin+Jones LabStudio," 4.

13. Sabin and Jones, "Nonlinear Systems Biology and Design"; and Buckminster Fuller, "Tensegrity," *Portfolio and Art News Annual* 4 (1961): 2–4, http://www.rwgrayprojects .com/rbfnotes/fpapers/tensegrity/tenseg01.html (accessed April 1, 2013).

14. Donald Ingber and J. D. Jamieson, "Cells as Tensegrity Structures: Architectural Regulation of Histodifferentiation by Physical Forces Transduced over Basement Membrane," in *Gene Expression during Normal and Malignant Differentiation*, ed. L. C. Andersson, C. G. Gahmberg, and P. Ekblom, 13–32 (Orlando: Academic Press, 1985); and Donald Ingber, "Cellular Tensegrity: Defining New Rules of Biological Design that Govern the Cytoskeleton," *Journal of Cell Science* 104 (1993): 613–27.

15. Neil Leach, "Digital Morphogenesis," *Architectural Design* 79, no. 1 (January/February 2009): 34.

16. Branko Kolarevic, "Digital Morphogenesis," in *Architecture in the Digital Age: Design and Manufacturing* (London: Taylor and Francis, 2005), 13.

17. Kolarevic, "Digital Morphogenesis," 26.

18. Jackie Wong, "Dance and Space," advanced research seminar, Form and Algorithm, Cecil Balmond and Jenny Sabin, PennDesign, 2016.

19. Katharine Miller, "Architectural Computation Visualizes Cell Choreography," *Biomedical Computation Review* (Summer 2010): http://biomedicalcomputationreview .org/content/architectural-computation-visualizes-cell-choreography (accessed January 10, 2019).

20. Popp, "Architect Walks into the Lab," 32. See also, Erica S. Savig, Mathieu C. Tamby, Jenny Sabin, and Peter Lloyd Jones, "Case Study: Understanding Behavioral Rule Sets through Cell Motility," in *LabStudio: Design Research between Architecture and Biology*, 201–14 (London: Routledge, 2018).

21. Rudolf von Laban, *Choreutics*, ed. Lisa Ullmann (London: Macdonald and Evans, 1966), 5.

22. Laban, *Choreutics*, 5.

23. William Forsythe, "Choreographic Objects," William Forsythe (website), http:// www.williamforsythe.de/essay.html (accessed June 1, 2013).

24. Forsythe, "Choreographic Objects."

25. Erin Manning, "Rhythmic Nexus: The Felt Togetherness of Movement and Thought," *INFLeXions* 2 (January 2009): http://www.inflexions.org/n2_manninghtml .html (accessed June 1, 2013).

26. Sabin and Jones, "Sabin+Jones LabStudio," 11.

4. VITAL ECOLOGIES

1. See Rachel Armstrong, *Living Architecture: How Synthetic Biology Can Remake Our Cities and Reshape Our Lives* (TED Books, 2012).

2. See Mark Bedau, Norman Packard, and Steen Rasmussen, *Protocells: Bridging Nonliving and Living Matter* (Cambridge, Mass.: MIT Press, 2008).

3. Rachel Armstrong and Neil Spiller, "It's a Brand New Morning," *Protocell Architecture* 81, no. 2 (March/April 2011): 21.

4. Lynn Margulis, *Symbiosis in Cell Evolution: Life and Its Environment on the Early Earth* (New York: W. H. Freeman and Co., 1981).

5. Lynn Margulis, *Symbiotic Planet: A New Look at Evolution* (New York: Basic Books, 1998).

6. Eugene Thacker, *Biomedia* (Minneapolis: University of Minnesota Press, 2004), 161.

7. Rachel Armstrong, *Living Chemistry*, exhibited at *Synth-ethics*, curated by Jens Hauser, Natural History Museum, Vienna, 2011, http://www.biofaction.com/synth-ethic/#rachel-armstrong.

8. Rachel Armstrong, "Future Venice: Growing an Artificial Reef under the City," En Vie/Alive (website), http://thisisalive.com/future-venice-growing-an-artificial-reef-under-the-city/.

9. Rachel Armstrong, "Future Venice," in *Bio-design: Nature Science Creativity*, ed. William Myers (New York: MOMA/Thames and Hudson, 2012), 72–73.

10. Rachel Armstrong and Neil Spiller, "Future Venice," University of Greenwich (website), http://www2.gre.ac.uk/about/schools/adc/research/centres/avatar/research/fv.

11. Armstrong and Spiller, "It's a Brand New Morning," 18.

12. Martin Hanczyc, "Structure and the Synthesis of Life," *Protocell Architecture* 81, no. 2 (March/April 2011): 31.

13. See Mark Bedau, Norman Packard, and Steen Rasmussen, *Protocells: Bridging Nonliving and Living Matter* (Cambridge, Mass.: MIT Press, 2008), 72.

14. Rachel Armstrong and Neil Spiller, "A Manifesto for Protocell Architecture: Against Biological Formalism," *Protocell Architecture* 81, no. 2 (March/April 2011): 24–25.

15. See, for example, Paul J. Crutzen, "Geology of Mankind," *Nature* 415, no. 3 (January 2002): http://nature.berkeley.edu/classes/espm-121/anthropocene.pdf; Paul J. Crutzen, "The 'Anthropocene,'" *Journal de Physique* 12, no. 10 (2002): 1–5; and Will Steffen, Paul J. Crutzen, and John R. McNeill, "The Anthropocene: Are Humans Now Overwhelming the Great Forces of Nature?," *Ambio* 36, no. 8 (December 2007): 614–21.

16. Philip Beesley, *Synthetic Earth* (1996), Philip Beesley Architect Inc. (website), http://philipbeesleyarchitect.com/sculptures/9605syntheticearth/index.php.

17. Philip Beesley, quoted in an interview with Christine Macy, "Disintegrating Matter, Animating Fields," in *Kinetic Architectures and Geotextile Installations*, by Philip Beesley (Cambridge, Ontario: Riverside Architectural Press, 2010), 30.

18. Philip Beesley, *Hungry Soil* (2000), Philip Beesley Architect Inc. (website), http://philipbeesleyarchitect.com/sculptures/0015hungry_soil/index.php.

19. Geoff Manaugh, "Synthetic Geology: Landscape Remediation in an Age of Benign

Geotextiles," in *Kinetic Architectures and Geotextile Installations,* by Philip Beesley (Cambridge, Ontario: Riverside Architectural Press, 2010), 45.

20. See Ernst Heinrich Haeckel, *The Riddle of the Universe,* trans. Joseph McCabe (New York: Prometheus Books, 1992).

21. For more on this mechanized system and Beesley's collaborators, see Jonah Humphrey, "Integrated Systems: The Breathing Cycle," Christian Joakim, "Topology and Geometry: The Hylozoic Mesh," William Elsworthy, "Component Design and Actuated Devices: An Evolutionary Process," and Rob Gorbet, "Revealing the Hylozoic Ground Interaction Layer," in *Hylozoic Ground: Liminal Responsive Architecture Installations,* by Philip Beesley (Cambridge, Ontario: Riverside Architectural Press, 2010), 78–123.

22. Cary Wolfe, "Queasy Posthumanism," in *Hylozoic Ground: Liminal Responsive Architecture Installations,* by Philip Beesley (Cambridge, Ontario: Riverside Architectural Press, 2010), 63.

23. See Elizabeth A. Povinelli, Mathew Coleman, and Kathryn Yusoff, "An Interview with Elizabeth Povinelli: Geontopower, Biopolitics, and the Anthropocene," in "Geosocial Formations and the Anthropocene," special issue, *Theory, Culture, and Society* 34, no. 2–3 (2017): 169–85.

24. Elizabeth A. Povinelli, *Geontologies: A Requiem to Late Liberalism* (Durham, N.C.: Duke University Press, 2016), 28.

5. VITAL REGENERATION

1. Patricia Piccinini, *Still Life with Stem Cells,* http://www.patriciapiccinini.net/Still +Life+With+Stem+Cells/.

2. Guy Ben-Ary and Kirsten Hudson, *In Potentia,* http://in-potentia.com.au/about, http://www.isea2013.org/. See also *Semipermeable (+)* exhibition, http://www.symbiotica .uwa.edu.au/activities/exhibitions/semipermeable-.

3. Kazutoshi Takahashi and Shinya Yamanaka, "Induction of Pluripotent Stem Cells from Mouse Embryonic and Adult Fibroblast Cultures by Defined Factors," *Cell* 126, no. 4 (August 2006): 663–76; and Kazutoshi Takahashi, Koji Tanabe, Mari Ohnuki, Megumi Narita, Tomoko Ichisaka, Kiichiro Tomoda, and Shinya Yamanaka, "Induction of Pluripotent Stem Cells from Adult Human Fibroblasts by Defined Factors," *Cell* 131, no. 5 (November 2007): 861–72.

4. Guy Ben-Ary, "In Potentia," YouTube video, 4:53, posted March 10, 2013, https:// www.youtube.com/watch?v=99S6TEDTow8.

5. Irving Weissman, "Purification and Characterization of Mouse Hematopoietic Stem Cells," *Science* (July 1, 1988): 58–62.

6. See Paul Knoepfler, *Stem Cells: An Insider's Guide* (London: World Scientific Publishing, 2013).

7. Insoo Hyun, *Bioethics and the Future of Stem Cell Research* (Cambridge: Cambridge University Press, 2013), 23–24.

8. Gail Martin, "Isolation of a Pluripotent Cell Line from Early Mouse Embryos Culture in Medium Conditioned by Teratocarcinoma Stem Cells," *Proceedings of the National Academy of Sciences of the United States of America* 78, no. 12 (1981): 7634–38; and Martin Evans and Matthew Kaufman, "Establishment in Culture of Pluripotent Cells from Mouse Embryos," *Nature* 292, no. 5819 (1981): 154–56.

9. James A. Thomson, Joseph Itskovitz-Eldor, Sander S. Shapiro, Michelle A. Waknitz, Jennifer J. Swiergiel, and Vivienne S. Marshall, "Embryonic Stem Cell Lines Derived from Human Blastocysts," *Science* 282, no. 5391 (November 1998): 1145–47; and James A. Thomson, Jennifer Kalishman, Thaddeus G. Golos, Maureen Durning, Charles P. Harris, Robert A. Becker, and John P. Hearn, "Isolation of a Primate Embryonic Stem Cell Line," *Proceedings of the National Academy of Sciences of the United States of America* 92 (August 1995): 7844–48.

10. Miguel Ramalho-Santos and Holger Willenbring, "On the Origin of the Term 'Stem Cell,'" *Cell Stem Cell* (July 2007): 35–38. For an overview of bioethical debates, see Hyun, *Bioethics and the Future of Stem Cell Research,* and Alice Park, *The Stem Cell Hope: How Stem Cell Medicine Can Change Our Lives* (New York: Plume, 2012).

11. Ramalho-Santos and Willenbring, "On the Origin of the Term," 35.

12. Ramalho-Santos and Willenbring, 36.

13. Ramalho-Santos and Willenbring, 37.

14. Hyun, *Bioethics and the Future of Stem Cell Research,* 25.

15. Hyun, 26.

16. 145 Cong. Rec. E1696 (daily ed. July 29, 1999) (statement of Representative Schafer). See also Philip B. C. Jones, "Funding of Human Stem Cell Research by the United States," *Electronic Journal of Biotechnology* 315, no. 4 (2000): http://www.ejbiotechnology.info/index.php/ejbiotechnology/article/view/v3n1–3/839#10.

17. Park, *Stem Cell Hope,* 35–108.

18. Alice Park, "Researchers Cheer Obama's Support of Stem Cell Science," *Time,* March 9, 2009, http://content.time.com/time/health/article/0,8599,1883861,00.html.

19. Linda F. Hogle, "Characterizing Human Embryonic Stem Cells: Biological and Social Markers of Identity," *Medical Anthropology Quarterly* 24, no. 4 (December 2010): 433.

20. Hogle, "Characterizing Human Embryonic Stem Cells," 433.

21. Hogle, 438.

22. Hogle, 438.

23. "Stem Cell Basics III: What Are Embryonic Stem Cells?," National Institutes of Health, http://stemcells.nih.gov/info/basics/pages/basics3.aspx.

24. Hogle, "Characterizing Human Embryonic Stem Cells," 439–40.

25. See Hannah Landecker, *Culturing Life: How Cells Became Technologies* (Cambridge, Mass.: Harvard University Press, 2007).

26. Martin, "Isolation of a Pluripotent Cell Line."

27. Thomson et al., "Embryonic Stem Cell Lines."

28. M. Amit, V. Margulets, H. Segev, K. Shariki, I. Laevsky, R. Coleman, and J. Itskovitz-Eldor, "Human Feeder Layers for Human Embryonic Stem Cells," *Biology of Reproduction* 68, no. 6 (2003): 2150–56; and M. Amit, C. Shariki, V. Margulets, and J. Itskovitz-Eldor, "Feeder Layer- and Serum-Free Culture of Human Embryonic Stem Cells," *Biology of Reproduction* 70, no. 3 (2004): 837–45.

29. Sarah Franklin, *Biological Relatives: IVF, Stem Cells, and the Future of Kinship* (Durham, N.C.: Duke University Press, 2013), 17.

30. Franklin, *Biological Relatives,* 19.

31. Donna Haraway, "Speculative Fabulations for Technoculture's Generations,"

originally published for the exhibition catalog *(tender) creatures*, Artium Museum, Araba, Spain (2007), http://www.patriciapiccinini.net/writing/30/127/81.

32. Paul Knoepfler, *Stem Cells: An Insider's Guide* (London: World Scientific Publishing, 2013), 36.

33. John Gurdon, T. R. Elsdale, and M. Fischberg, "Sexually Mature Individuals of *Xenopus laevis* from the Transplantation of Single Somatic Nuclei," *Nature* 182 (July 5, 1958): 64–65.

34. Angelika E. Schnieke, Alexander J. Kind, William A. Ritchie, Karen Mycock, Angela R. Scott, Marjorie Ritchie, Ian Wilmut, Alan Colman, and Keith H. S. Campbell, "Human Factor IX Transgenic Sheep Produced by Transfer of Nuclei from Transfected Fetal Fibroblasts," *Science* 278, no. 5346 (December 19, 1997): 2130–33.

35. National Bioethics Advisory Commission, *Cloning Human Beings: Report and Recommendation of the National Bioethics Advisory Commission*, June 1997, https://bioethicsarchive.georgetown.edu/nbac/pubs/cloning1/cloning.pdf.

36. See Anne McLaren, "Cloning: Pathways to a Pluripotent Future," *Science* 288, no. 5492 (June 9, 2000): 1775–80.

37. See Park, *Stem Cell Hope*, 187–218.

38. In 2012, John Gurdon and Shinya Yamanaka shared the Nobel Prize in Physiology or Medicine.

39. See Hyun, *Bioethics and the Future of Stem Cell Research*, 31–33.

40. Takahashi and Yamanaka, "Induction of Pluripotent Stem Cells."

41. Takahashi et al., "Induction of Pluripotent Stem Cells"; and Junying Yu, Maxim A. Vodyanik, Kim Smug-Otto, Jessica Antosiewicz-Bourget, Jennifer F. Frane, Shulan Tian, Jeff Nie, Gudrun A. Jonsdottir, Victor Ruotti, Ron Stewart, Igor I. Slukvin, and James A. Thomson, "Induced Pluripotent Stem Cell Lines Derived from Human Somatic Cells," *Science* 318, no. 5858 (December 21, 2007): 1917–20.

42. Luigi Warren, Philip D. Manos, Tim Ahfeldt, Yuin-Han Loh, Hu Li, Frank Lau, Wataru Ebina, Pankaj K. Mandal, Zachary D. Smith, Alexander Meissner, George Q. Daley, Andrew S. Brack, James J. Collins, Chad Cowan, Thorsten M. Schlaeger, and Derrick J. Rossi, "Highly Efficient Reprogramming to Pluripotency and Directed Differentiation of Human Cells with Synthetic Modified mRNA," *Cell Stem Cell* 7, no. 5 (November 5, 2010): 618–30.

43. Landecker, *Culturing Life*, 11.

44. Hyun, *Bioethics and the Future of Stem Cell Research*, 31.

45. "*In Potentia*: About," Guy Ben-Ary (website), http://in-potentia.com.au/about.

46. "*CellF*: About," Guy Ben-Ary (website), http://guybenary.com/work/cellf/#About.

47. "*CellF*: The Process," Guy Ben-Ary (website), http://guybenary.com/work/cellf/#The_Process.

48. Catherine Malabou, "A Conversation with Catherine Malabou," *Journal for Cultural and Religious Theory* 9, no. 1 (Winter 2008): 6, http://www.jcrt.org/archives/09.1/Malabou.pdf.

49. Hyun, *Bioethics and the Future of Stem Cell Research*, 34–35.

50. Hyun, 34.

51. Hogle, "Characterizing Human Embryonic Stem Cells," 444.

52. Hogle, 446.

53. Haruko Obokata, Teruhiko Wakayama, Yoshiki Sasai, Koji Kojima, Martin P. Vacanti, Hitoshi Niwa, Masayuki Yamato, and Charles A. Vacanti, "Stimulus-Triggered Fate Conversion of Somatic Cells into Pluripotency," *Nature* 505 (2014): 641–47; and Haruko Obokata, Yoshiki Sasai, Hitoshi Niwa, Mitsutaka Kadota, Munazah Andrabi, Nozomu Takata, Mikiko Tokoro, Yukari Terashita, Shigenobu Yonemura, Charles A. Vacanti, and Teruhiko Wakayama, "Bidirectional Developmental Potential in Reprogrammed Cells with Acquired Pluripotency," *Nature* 505 (2014): 676–80.

54. Comments on "Stimulus-Triggered Fate Conversion of Somatic Cells into Pluripotency," PubPeer, https://pubpeer.com/publications/8B755710BADFE6FB0A848A44B70F7D.

55. Tracy Vence, "Final Straw for STAP?," *Scientist,* June 4, 2014, http://www.the-scientist.com/?articles.view/articleNo/40132/title/Final-Straw-for-STAP-/.

56. David Cyranoski, "Gene Tests Suggest Acid-Bath Stem Cells Never Existed," *Nature,* Breaking News, June 17, 2014, http://www.nature.com/news/gene-tests-suggest-acid-bath-stem-cells-never-existed-1.15425.

57. Haruko Obokata, Yoshiki Sasai, Hitoshi Niwa, Mitsutaka Kadota, Munazah Andrabi, Nozomu Takata, Mikiko Tokoro, Yukari Terashita, Shigenobu Yonemura, Charles A. Vacanti, and Teruhiko Wakayama, "Retraction: Bidirectional Developmental Potential in Reprogrammed Cells with Acquired Pluripotency," *Nature* 511 (July 2, 2014), http://www.nature.com/nature/journal/v511/n7507/full/nature13598.html; and Haruko Obokata, Teruhiko Wakayama, Yoshiki Sasai, Koji Kojima, Martin P. Vacanti, Hitoshi Niwa, Masayuki Yamato, and Charles A. Vacanti, "Retraction: Stimulus-Triggered Fate Conversion of Somatic Cells into Pluripotency," *Nature* 511 (July 2, 2014), http://www.nature.com/nature/journal/v511/n7507/full/nature13599.html.

58. Andrew Pollock, "After Controversy, Stem Cell Papers Are Retracted," *New York Times,* July 2, 2014, http://www.nytimes.com/2014/07/03/business/stem-cell-research-papers-are-retracted.html.

59. "Suicide of STAP Scientist Delays Verification Experiment," *Asahi Shimbun,* August 6, 2014, http://ajw.asahi.com/article/behind_news/social_affairs/AJ201408060040.

60. Denis Normile, "In Japan, Official Effort to Replicate STAP Stem Cells Comes Up Empty," *Science,* August 27, 2014, http://news.sciencemag.org/asiapacific/2014/08/japan-official-effort-replicate-stap-stem-cells-comes-empty.

61. David Cyranoski, "STAP Co-author Offers Yet Another Recipe for Stem Cells," *Nature News* (blog), September 12, 2014, http://blogs.nature.com/news/2014/09/stap-co-author-offers-yet-another-recipe-for-stem-cells.html.

62. David Cyranoski, "Still No Stem Cells via Easy 'STAP' Path," *Nature News* (blog), December 18, 2014, http://www.nature.com/news/still-no-stem-cells-via-easy-stap-path-1.16606?utm_source=dlvr.it&utm_medium=tumblr.

63. Heidi Ledford, "Contamination Produced Controversial 'Acid-Induced' Stem Cells," *Nature News* (blog), December 26, 2014, http://blogs.nature.com/news/2014/12/contamination-created-controversial-acid-induced-stem-cells.html.

64. Patricia Piccinini, artist's statement, *Still Life with Stem Cells,* originally published at Biennale of Sydney (2002), http://www.patriciapiccinini.net/writing/24/127/81.

65. Piccinini, "In Another Life."

EPILOGUE

1. Yuyu Niu, Bin Shen, Yiqiang Cui, Yongchang Chen, Jianying Wang, Lei Wang, Yu Kang et al., "Generation of Gene-Modified Cynomolgus Monkey via Cas9/RNA-Mediated Gene Targeting in One-Cell Embryos," *Cell* 156, no. 4 (2014): http://dx.doi.org/10.1016/j.cell.2014.01.027.

2. Alex Reis, Breton Hornblower, Brett Robb, and George Tzertzinis, "CRISPR/Cas-9 and Targeted Genome Editing: A New Era in Molecular Biology," *New England BioLabs Expressions* 1 (2014), https://www.neb.com/tools-and-resources/feature-articles/crispr-cas9-and-targeted-genome-editing-a-new-era-in-molecular-biology.

3. David Baltimore, Paul Berg, Michael Botchan, Dana Carroll, R. Alta Charo, George Church, Jacob E. Corn et al., "A Prudent Path Forward for Genomic Engineering and Germline Gene Modification," *Science* 348, no. 6230 (April 3, 2015): 36–38; and Edward Lanphier, Fyodor Urnov, Sarah Ehlen Haecker, Michael Werner, and Joanna Smolenski, "Don't Edit the Human Germline," *Nature* 519, no. 7544 (March 26, 2015): http://www.nature.com/news/don-t-edit-the-human-germ-line-1.17111.

4. Puping Liang, Yanwen Xu, Xiya Zhang, Chenhui Ding, Rui Huang, Zhen Zhang, Jie Lv et al., "CRISPR/Cas9-Mediated Gene Editing in Human Tripronuclear Zygotes," *Protein & Cell* 6, no. 5 (May 2015): 363–72, https://doi.org/10.1007/s13238-015-0153-5.

5. Hong Ma, Nuria Marti-Gutierrez, Sang-Wook Park, Jun Wu, Yeoni Lee, Keiichiro Suzuki, Amy Koski et al., "Correction of a Pathogenic Gene Mutation in Human Embryos," *Nature* 548 (August 24, 2017): 413–19, https://doi.org/10.1038/nature23305.

6. David Cyranoski and Heidi Ledford, "Genome-Edited Baby Claim Provokes International Outcry," *Nature News* (blog), November 26, 2018, https://www.nature.com/articles/d41586-018-07545-0 (accessed January 11, 2019).

7. David Cyranoski, "First CRISPR Babies: Six Questions That Remain," *Nature News* (blog), November 30, 2018, https://www.nature.com/articles/d41586-018-07607-3 (accessed January 11, 2019).

8. Elizabeth A. Povinelli, *Geontologies: A Requiem to Late Liberalism* (Durham, N.C.: Duke University Press, 2016).

9. *Future Emerging Art and Technology* exhibition, University of Dundee, Dundee, Scotland (April 13–June 17, 2017), http://www.featart.eu/index.php?id=5.

10. "Future Emerging Art and Technology: Make Do and Mend," *Anna Dumitriu: Bioart and Bacteria* (blog), http://annadumitriu.tumblr.com/FEAT. Another version of the work, titled *Controlled Commodity 1941*, was exhibited at Zone2Source in Amsterdam from May 13 to June 2017. See "Trust Me, I'm an Artist: Controlled Commodity," *Anna Dumitriu: Bioart and Bacteria* (blog), http://annadumitriu.tumblr.com/TrustMe.

11. Anna Dumitriu and Sarah Goldberg, "*Make Do and Mend*: Exploring Gene Regulation and CRISPR through a FEAT (Future Emerging Art and Technology) Residency with the MRG-Grammar Project," *Leonardo* (forthcoming): https://doi.org/10.1162/LEON_a_01466.

12. Adam Zaretsky, "Open Letter of Extensive Arguments to Whom It May Concern at Office Genetically Modified Organisms," http://ja-natuurlijk.com/site2/files/2013/01/Twelve-page-extensive-Arguments-to-the-public-Adam-Zaretsky.pdf. Also Adam Zaretsky, email conversation, June 27, 2017.

13. Adam Zaretsky, "CentiSperm: Methods of Transgenesis: Shoot, Shock, Inject,

Experiments in Biolistics, Electroporation, and Microinjection," in *Taboo-Transgression-Transcendence: Proceedings of the Interdisciplinary Conference, Ionian University* (Corfu, Greece: 2017), 71–98; Marie Mart Roijackers, "Doing the Taboo: Examining Affect and Participation in Bioart" (master's thesis, Leiden University, August 31, 2015); and VASTALschool, "CERN-Worm™ Eats MicroSushi," YouTube video, 5:14, posted June 19, 2017, https://www.youtube.com/watch?v=qJcJA4KE7EU.

14. Eben Kirksey, "Who's Afraid of CRISPR Art?," *Somatosphere,* March 9, 2016, http://somatosphere.net/2016/03/who-is-afraid-of-crispr-art.html.

INDEX

JENNIFER JOHUNG is associate professor in the Department of Art History at the University of Wisconsin–Milwaukee. She is the author of *Replacing Home: From Primordial Hut to Digital Network in Contemporary Art* (Minnesota, 2011) and the coeditor of *Landscapes of Mobility: Culture, Politics, and Placemaking.*